ERO

for the SERIOUS BE

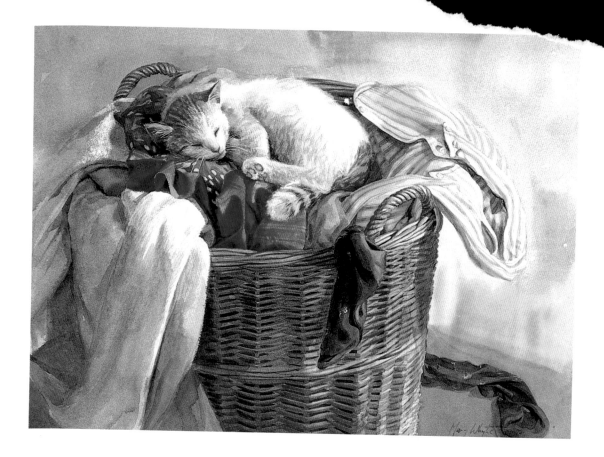

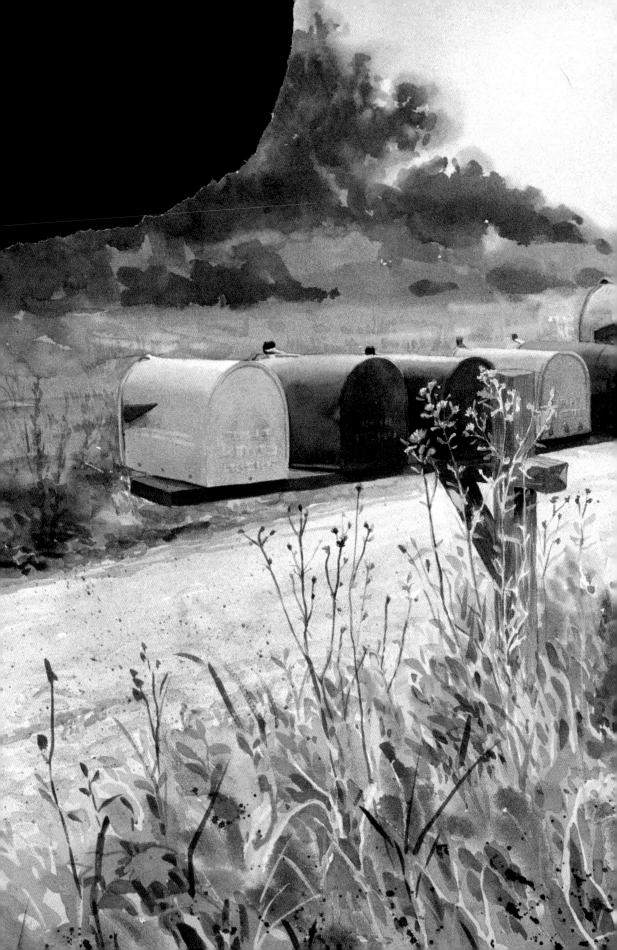

WATERCOLOR

for the SERIOUS BEGINNER

Mary Whyte

WATSON-GUPTILL PUBLICATIONS/NEW YORK

TO SMITTY, MY HUSBAND AND COMPANION.

ACKNOWLEDGMENTS

My special thanks to the editors and staff of Watson-Guptill Publications, as well as to the manufacturers, artists, and museums who so generously contributed to the making of this book. I also wish to acknowledge my assistants, Evan Gatti and Sarah Myles, whose tireless help and encouragement throughout the entire project were invaluable.

Finally, my deepest gratitude goes to my husband, Smith Coleman, for his superb photographs and endless support, and for sharing me all these years with my other true love—watercolor.

Frontispiece:
Mary Whyte
CATNAP
Watercolor on paper, 20 × 26" (51× 66 cm), 1992.
Collection of Carol Barnes.

Title page:
Mary Whyte
GOIN' HOME
Watercolor on paper, 20 × 26" (51 × 66 cm), 1993.
Collection of Mrs. and Mrs. Robert Applegate.

Edited by Robbie Capp
Designed by Areta Buk
Graphic production by Hector Campbell
Text set in Adobe Garamond

First published in 1997 in the United States by
Watson-Guptill Publications,
a division of BPI Communications, Inc.,
770 Broadway, New York, NY 10003

Library of Congress Cataloging-in-Publication Data

Whyte, Mary.
 Watercolor for the serious beginner / Mary Whyte.
 p. cm.
 Includes index.
 ISBN 0-8230-5660-0
 1. Watercolor painting—Technique. I. Title.
 ND2420.W52 1997
 751.42'2—dc21 97-18887
 CIP

Manufactured in China

First printing, 1997

4 5 6 7 8 / 04 03 02 01 00

About the Author
A graduate of Tyler School of Art in Philadelphia, Mary Whyte has worked as a professional artist since 1977. Her watercolors have appeared in many prominent national shows, including exhibitions organized by the American Watercolor Society and the Allied Artists of America. Her work is included in numerous private, corporate, and public collections throughout the United States. Mary and her husband, Smith Coleman, own an art gallery in Charleston, South Carolina, near where they live.

Contents

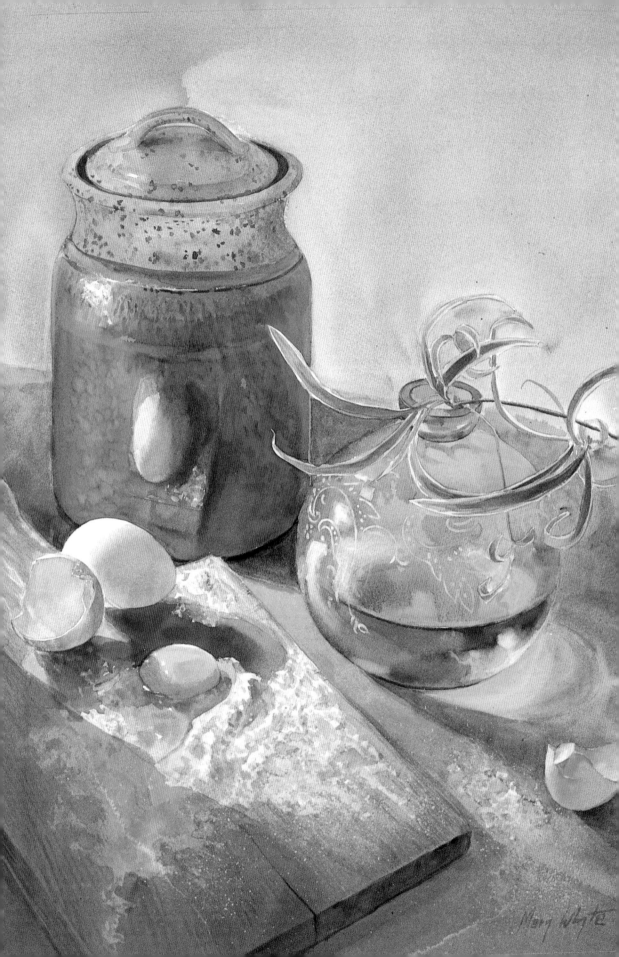

Introduction

Several years ago, I was meandering through a flea market and happened across a framed watercolor painting. Upon closer inspection I recognized the artist's signature, and from the date on the watercolor estimated that he was probably in his early twenties when he made the painting. It was, by and large, one of the most dismal, poorly executed watercolors I had ever seen. I wish I had bought it.

I would like to have that painting now so that I could show it to my students who are struggling with the art of watercolor. The maker of that particular painting is now a highly respected, nationally known artist credited for his strong work. He, like all successful painters, started as a novice and persevered to become the fine artist he is today.

I like the title of this book, because it speaks to readers who have a strong desire to succeed as artists. Watercolor takes patience, practice, and serious effort. Admittedly, talent plays a part, but ultimately, it is up to you to decide how hard you're going to apply yourself to do the most with your talent.

This book is not just about technique. It is also about seeing and thinking. As shown by the many different examples of watercolors in these pages, there is no one "right" way to paint, no true way to achieve "pure" watercolor. The only right way for a watercolor to look is as if only *you* could have painted it.

Mary Whyte
THE EGG AND I
Watercolor on paper,
23 × 20" (58 × 76 cm), 1996.
Private collection.

Successful still-life paintings begin with the character of the objects. In this painting, each of the objects has a distinctly different texture and shape, yet they are all unified by the light pattern and design of the composition. All of the objects were found in my kitchen.

THE TRADITION OF WATERCOLOR

The first use of watercolor is generally attributed to the English. As early as the 1700s, elaborate prints of the landscape were tinted in watercolor to please an ever-increasing market. The English aristocracy frequently hired watercolorists to accompany them on their travels to document the scenery. Watercolor became a quick, portable means of expression. In truth, the very earliest watercolor can be traced back as far as the ancient Egyptians, Greeks, and Romans. During the Middle Ages, and later, during the Renaissance, manuscripts were illuminated in watercolor by monks.

Watercolor did not take hold in America until the late 1800s. The sudden popularity of the medium could be attributed to two factors: the newly manufactured, more affordable paints and papers that became widely available to the public, and an important exhibition in 1873 at the National Academy of Design in New York, devoted exclusively to nearly six hundred watercolor paintings. The show inspired Winslow Homer (1836–1910) to embark on a new career in that medium. Homer's oil paintings had debuted at the Academy to great acclaim ten years earlier, and he was also established as a fine magazine illustrator. But the exhibition in 1873 was pivotal to Homer's development, and he would soon produce some of the most important watercolors of the late nineteenth century. Homer's stunning work became a turning point for the critical acceptance of the medium and continues to have a profound effect on watercolorists.

In recent years, watercolor has evolved in diverse ways. Acrylic-based paints and resists, water-based drawing pigments, and computer-generated art are all being interwoven with watercolor to create rich new forms of expression. Other watercolor materials and techniques will no doubt continue to unfold, but the spirited, lively nature of the medium will forever stay the same.

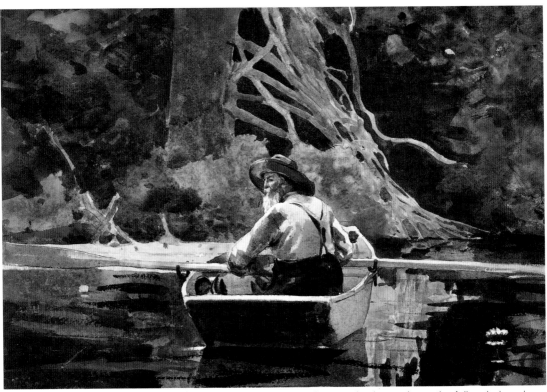

Winslow Homer
THE ADIRONDACK GUIDE
Watercolor on paper, 15 1/8 × 21 1/2"
(38 × 54 cm), 1894. Courtesy of
Museum of Fine Arts, Boston.
Bequest of Alma H. Wadleigh.

In the 1890s, Winslow Homer made several arduous trips to the Adirondacks, where he produced a series of watercolors of hunters, fishermen, and landscapes. Very often friends would act as his models, including the "guide" in this painting. Homer's work would have a profound impact on the way watercolor is viewed in America.

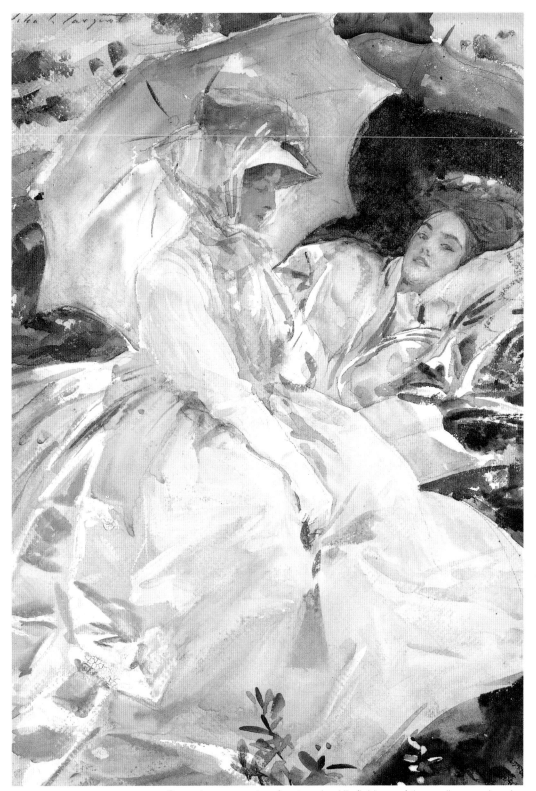

John Singer Sargent
SIMPLON PASS: READING
Watercolor on paper, 20 × 14"
(51 × 36 cm), undated. Courtesy of
Museum of Fine Arts, Boston.
Charles Henry Hayden Fund.

Sargent was a master of watercolor. His fluid use of the medium employed wet-into-wet techniques as well as crisp, calligraphic brushstrokes. Notice how the artist uses both warm yellows and cool violets to produce the effect of luminous whites.

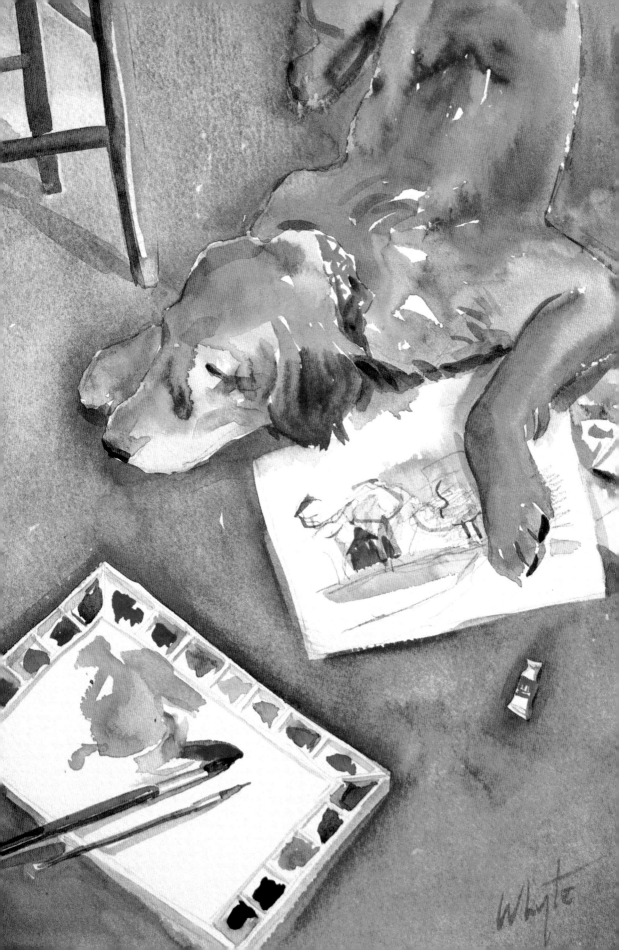

Materials

When I was sixteen, I was awarded a scholarship to attend a watercolor class at a local art center. Up until then, I had used the materials available to me at our public school and thought all artists used manila paper, an inexpensive brush, and a small watercolor set with a total of six cake colors. I had assumed that the dismal results I was getting stemmed from my total lack of experience.

The instructor sent me home with a list of supplies. How surprised I was to discover that watercolors came in small tubes and that one could buy just a single sheet of paper at a time. After purchasing everything on the list, I started painting. I never knew colors could be so brilliant or that a brush could be so versatile! It amazed me that paper could have such a heavenly feel and actually hold the watercolor. I never knew a palette could have so much room for mixing large, exciting washes.

Since then, I have been an advocate of good supplies. While it is true that an accomplished painter can paint with almost anything, superior materials can bring the beginning watercolorist closer to his or her goals faster. Fine materials also give longevity to your work. Inferior paints are guaranteed to fade; cheap paper will yellow and turn brittle. Being married to a conservator, I have seen too many works come into the gallery in need of restoration because the artist did not use quality materials.

Good painting supplies are expensive. While most people need to adhere to a strict budget, scrimping on materials is generally not worth it. So in this chapter, I will recommend only quality materials, with a few suggestions for more value-priced items. With proper care, many supplies will last a long time—which often makes them the most economical to use, after all.

Mary Whyte
STUDIO CLUTTER
Watercolor on paper,
11 × 8" (28 × 20 cm), 1996.
Private collection.

Good painting materials, along with a thorough understanding of how they are used, are essential for the serious beginner in the watercolor medium. Of course, a little moral support and companionship never hurt either.

Brushes

Perhaps the most important tool for the watercolorist is the brush. An extension of the artist's hand and mind, the brush should be of a responsive quality ready to perform as needed.

A quick study of any art supply catalogue will reveal that the watercolorist has an almost limitless choice of brush shapes and sizes from which to choose. Likewise, the price of watercolor brushes, depending on the materials from which they are made, can range from a couple of dollars to several hundred per brush. The beginning artist does not need an entire arsenal of brushes. A few well-made ones will offer the versatility and durability needed.

The basic brush styles for watercolor are wash, round, flat, bright (short and flat), oval mop, filbert (almond-shape), script, or rigger. (When and how to use particular styles will be discussed in the course of demonstrations given later in this book.) The numbering system for brush sizes goes from #000 (thinnest) in some styles up to #20 (fattest), and wash brushes are numbered with their actual measurement—from one to several inches wide.

It's fair to say that regardless of shape, the finest watercolor brushes are universally acknowledged to be those made of red sable hair. "Sable" is actually a misnomer, since the hairs grow on different families of weasel. The most prized hairs for brush making come from the kolinsky, the Siberian, and the Manchurian marten—animals that are indigenous to cold regions. Kolinsky hair is so valued for its resilience and snap that it can cost more per ounce than gold.

Since there are several grades of sable hair, the beginning artist should invest only in a brush made by a reputable manufacturer. My own preference is for fine kolinsky brushes made by Isabey and Winsor & Newton. For the student artist on a tighter budget, the Dick Blick catalogue (see "Purchasing Supplies," page 18) offers a kolinsky brush that is of satisfactory quality. Some other suitable hairs that make up watercolor brushes are ox hair, goat, squirrel, and pony. More recently, synthetic fiber brushes made from nylon filament have gained acceptance. Additionally, a wide range that combine synthetic and natural hair blends have proven most successful, such as the Winsor & Newton Sceptre series and the Isabey Syrus brush. Both are considerably less expensive than kolinsky brushes and perform beautifully.

The finest watercolor brushes are made from kolinsky sable, such as the Winsor & Newton series 7 and the Isabey 6228 and 6227Z series. Brushes vary slightly in length and construction of the hair, which will affect the amount of wash held and the snap of the brush.

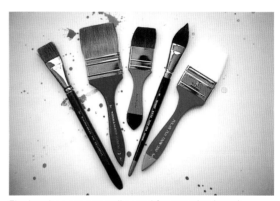

Flat brushes are generally used for covering broad areas and for the application of fluid washes. Shown are Grumbacher's 1" synthetic blend; Winsor & Newton's 2" golden synthetic goat blend; Isabey's 1 1/2" pure gold squirrel and their pure squirrel cat's tongue brush; and Polar-Flo's white filament hair brush.

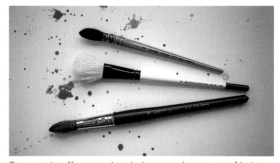

For certain effects and techniques, other types of hair may prove more satisfactory than sable. The beginning watercolorist should experiment with a wide variety of brush styles, sizes, and shapes to find those that best meet individual requirements. Shown are Utrecht's #40 sablette; Winsor & Newton's white goat hair mop; and Isabey's pure squirrel quill wash brush.

DISTINGUISHING THE GOOD FROM THE BAD

A simple way to test the quality of a watercolor brush is by giving it what I call the "whack test." Wet the brush hairs thoroughly with clean water, then lightly whack the handle against a table edge. A quality brush will snap back to a perfect point, while an inferior brush will flop over and the hairs will splay apart. With which brush would you rather paint?

CARING FOR YOUR BRUSHES

- Never leave a brush standing in water. The brush will lose its shape and the water will loosen the ferrule (the metal collar that holds the brush hairs) from the wooden handle.
- When rinsing your brushes, wipe them on a clean paper towel, rag, or sponge. A round brush should be wiped by pulling and turning it, so that the brush always comes away properly pointed.
- Although I have never experienced it, I have heard that moths are attracted to some brushes. As a precaution, put a few moth crystals in the box where you store your brushes. Be sure to keep the crystals from touching brush hairs.
- Don't put a brush in your mouth to wet and point it, and don't handle brush hairs. The oils from your fingers will collect at the base of the ferrule, making it swell and thus lose its proper shape.
- Never use soap or hot water to clean your brushes. Simply rinse them in cool water and let them dry. Store them in a dry place.
- Store your brushes so that they don't touch one another and so that nothing presses against the hair. This way, your brushes will always retain a perfect point.

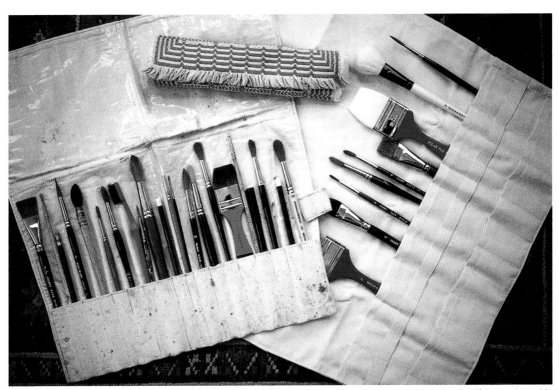

At left, this brush holder, made for me by a student, holds all my brushes, including small bristles for lifting and an old toothbrush for spattering. At center, an economical brush holder was made from an old placemat with an elastic strip tacked across it at one-inch intervals, into which the brushes are inserted; the placemat is easily rolled up for transport. At right is a brush holder that is available through most art supply stores and catalogue houses.

Paints

Watercolor paints come in three basic forms: fluid tube colors, semimoist pans (and half pans), and dry cakes or pans. Professional painters and other serious watercolorists generally use tube colors, since they are more conducive to large, rich washes, offered in sizes measured in milliliters. The most usual sizes are 5ml (.17 fl. oz), 14ml (.47 fl. oz.), and sometimes 37ml (1.25 fl. oz.), a large, studio-size tube.

Whichever form it comes in, watercolor, like all paint, is made up of three components: pigment, binder, and vehicle. The pigment is what gives us the color and, depending on the availability of the pigment, determines the price. For example, earth colors such as burnt sienna and yellow ochre generally cost less because their pigments are more readily available. They are also the most lightfast colors. Certain blues and reds can be exorbitant in price, since their pigments are more difficult to obtain or manufacture.

The binder is traditionally gum arabic, which formerly had a tendency to crack, until artists thought of adding sugar or honey to increase fluidity. Today, glycerin is used in addition to gum arabic as a wetting agent, though some manufacturers still use honey in their watercolor paints.

The vehicle in watercolor is, of course, water. Some artists use distilled water, but I have never seen it make much of a difference. The most important rule is to keep the water clean. Dirty water will gray all subsequent colors.

GRADES OF PAINT

While many watercolors will fade somewhat with time, today's paints are more lightfast than ever before. Most manufacturers conduct their own lightfast tests as well as have their products undergo evaluation by the American Society for Testing and Materials (ASTM), whose ratings are printed on all tubes of paint. However, not all lightfastness tests and pigments are created equal, with the ASTM standards revised or reapproved from time to time. Nonetheless, many manufacturers have improved the durability of their paints in recent years, promising greater longevity for the works of watercolorists.

You will discover that different manufacturers have different opinions as to the look and character of a color. The serious beginning artist is well advised to try as many different brands of paints as possible. Of the numerous excellent-quality watercolors found at art supply stores my own favorites are Sennelier, Winsor & Newton, and M. Graham and Company. Other manufacturers that offer equally good watercolors are Grumbacher, Schmincke, Rowney, Da Vinci, Holbein, Rembrandt, and Daniel Smith. Several manufacturers make a more economical or student-grade paint. Such brands include Grumbacher's Academy, Winsor & Newton's Cotman, and Rembrandt's Van Gogh. Generally half the price of their professional counterparts, student-grade paints are also slightly less brilliant.

PAINT CHARACTERISTICS

Although we generally think of watercolor as being transparent, not all hues are see-through. Each pigment has its own characteristics. Pigment colors fall into four categories: transparent, opaque, granulating, and staining. The color chart (opposite) identifies categories for each of thirty-six colors.

Several colors can also be considered unsaturated, meaning they are mixed from two or more pigments, making them slightly less pure and less transparent. It's important for you to be able to recognize different characteristics of pigments, as this knowledge will have a definite impact on your results. For example, depicting fog or painting skin tones might require the use of transparent colors, while more opaque colors might be better choices for painting rocks and trees. Transparent colors mix well with other colors and always appear fresh, as long as they are light enough for the white paper to show through. Opaque colors allow little paper to show through and are best used by themselves or mixed with a transparent color. Two opaque colors mixed together can look dull and chalky. Experiment with different mixtures to discover which combinations work best.

Watercolors are available in tubes or pans. Each color is marked with a rating for lightfastness.

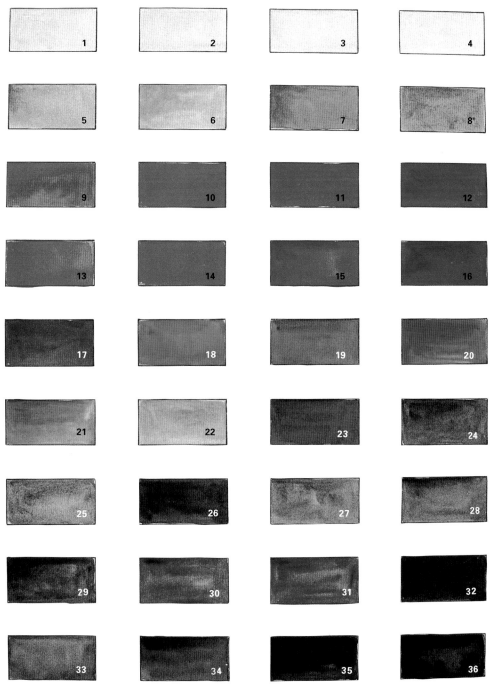

This color chart shows which hues are considered transparent, opaque, granulating, or staining. *Staining* colors saturate the paper and are difficult to lift or soften. *Granulation* occurs when pigment settles in the valleys of the watercolor paper, giving a grainy-looking texture.

1. CADMIUM YELLOW LIGHT—OS
2. AUREOLIN—TS
3. TRANSPARENT YELLOW—TS
4. LEMON YELLOW—O
5. YELLOW OCHRE—O
6. GAMBOGE—T
7. GOLD OCHRE—TS
8. RAW SIENNA—TG
9. CADMIUM ORANGE—O
10. SCARLET LAKE—TS
11. CADMIUM RED LIGHT—OS
12. CADMIUM RED—OGS
13. CADMIUM SCARLET—OS
14. PERMANENT ROSE—TS
15. ALIZARIN CRIMSON—TS
16. QUINACRIDONE VIOLET—TG
17. DIOXAZINE PURPLE—TG
18. FRENCH ULTRAMARINE BLUE—TG
19. WINSOR BLUE—TS
20. COBALT BLUE—TG
21. CERULEAN BLUE—OG
22. MANGANESE BLUE—TG
23. PHTHALO BLUE—TS
24. PHTHALO GREEN—TS
25. VIRIDIAN—TG
26. HOOKER'S GREEN—TS
27. PERMANENT GREEN LIGHT—TS
28. SAP GREEN—T
29. RAW UMBER—TG
30. BURNT UMBER—T
31. BURNT SIENNA—T
32. SEPIA—O
33. VAN DYKE BROWN—TS
34. INDIGO—OS
35. IVORY BLACK—OG
36. PAYNE'S GRAY—OS

KEY:
T = TRANSPARENT
O = OPAQUE / SEMI-OPAQUE
S = STAINING COLOR
G = GRANULATING COLOR

Paper and Support Boards

The surface quality of the paper you select will have a profound effect on the look of your finished painting. Certain papers are more agreeable than others to specific techniques, thus allowing or inhibiting the artist's intentions. The paper's unique characteristics include its texture, whiteness, and sizing. *Sizing* refers to a manufacturing process whereby a glutinous substance is added to paper pulp to fill up pores as a protective agent, thus allowing watercolor washes to move and mingle before settling into the paper's fibrous surface.

Watercolor paper surfaces fall into three categories: rough, cold-pressed, and hot-pressed. Surfaces vary from company to company. Rough paper has the most texture, with pronounced peaks and valleys that produce white sparkles when a loaded brush skips over the surface. Cold-pressed paper is the most versatile and agreeable of the papers, as it allows for more controlled washes and an even flow of color. Hot-pressed paper is the smoothest. Its slick surface will make colors appear more brilliant, but it will not allow successive glazes, since pigment doesn't hold to this paper as well as it does to others. The advantage to hot-pressed paper is that washes lift out easily, making for wonderful soft edges and luminous lights.

Watercolor paper is sold in individual sheets of standard sizes and weights. Traditional sizes are sometimes called imperial (22 × 30"), elephant (29^1/$_2$ × 40"), and double elephant (40 × 60"). The thickness of the paper is described by weight, based on what a ream of 500 sheets weighs. Offered are 90 lb., 140 lb., 200 lb., 260 lb., 300 lb., and the heaviest, 555 lb.

From left to right, handmade, rough, cold-pressed, and hot-pressed papers.

Good watercolor papers are either handmade, mold-made, or machine-made, and are composed of pure cotton or pure rag. Less expensive papers, made of wood pulp or blends, do not have the same durability as cotton or linen rag.

Several manufacturers make wonderful papers that are just as right for the beginning artist as for the professional. Fabriano, Arches, Whatman, Winsor & Newton, and T. H. Saunders produce some of the finest papers in the world. The best advice I can give a beginning watercolor artist is to try them all. Most companies offer small sample packs of their different papers, allowing artists to experiment. Eventually, you'll discover a paper that is meant for your style and temperament. My own preferences are Arches and Winsor & Newton 140-lb. cold-pressed papers, both of which have forgiving and durable surfaces. Since I add many layers of paint and also scrub, sponge, and lift out, I find these papers to be the most compatible with my work habits.

Handmade papers, though costly, contain cotton or linen-rag fibers and have a natural beauty that is unsurpassed. Such exquisite papers are made by Fabriano, Twinrocker, J. B. Green, and St. Armand.

Watercolor paper is also available in 90-lb. or 140-lb. blocks of 20 to 25 sheets. The size of the paper is usually no larger than 18 × 24", making blocks easy to transport for outdoor painting. Since sheets of paper are bound together in a block, they are kept rigid and don't have to be stretched. When you've finished painting on the top sheet, you just slice under its edges, peel off that sheet, and go on to the next. The one drawback to watercolor blocks is that the paper has not been prestretched. Excessive washes will cause the paper to expand and "buckle," making detail painting a little trickier. Spiral books, though handy for outdoor sketching, have the same limitation.

Students often ask, "Which side of the paper should I paint on?" Though each surface is slightly different, it doesn't seem to matter. I just grab a piece of paper, stretch it, and start painting.

BOARDS

Watercolor paper needs to be supported on a flat, stable surface during the painting process. The best painting support I've found is called Gatorboard, a lightweight, waterproof board available through many art suppliers and catalogue companies like Art Express (see "Purchasing Supplies," page 18). It is

somewhat similar to the foam board framers use to back a painting, but superior as a support because it won't warp if it gets wet. Gatorboard weighs little more than cardboard and is less cumbersome, especially for plein-air painting.

My second choice for a paper support would be Homosote, a heavy fiberboard sold at lumberyards. If you use Homosote, be sure to seal it with a coat of acrylic paint so that the acid from the board does not bleed into the back of the paper. Quarter-inch plywood can be used as long as it is sealed, but adding and removing staples will be difficult.

For attaching the paper to the board, you will need a good hand-held staple gun and an ample supply of staples. Some artists attach their paper to the board with brown packing tape, a procedure that I would not advise, as the tape will discolor the paper and can be difficult to remove.

STRETCHING PAPER

Unless the paper you select is 300-lb. weight or heavier, it will need to be stretched. There are two reasons why. First, you must prevent the paper from buckling during the painting process, which would cause washes to puddle in the valleys. The second reason is to break up the sizing on the surface of the paper. While sizing protects the paper surface, it also slightly inhibits initial washes from locking into the paper fibers. Stretching the paper or even lightly wetting it is enough to break up the sizing.

There are several ways to stretch paper. I have tried them all, and consider the method illustrated below to be the fastest, easiest, and most foolproof. I stretch my paper at the end of the day so that it's dry by the next morning. Placing wet paper under a ceiling fan will speed up drying time, as will a hair dryer, used at a low temperature setting.

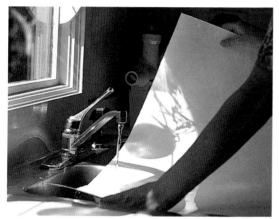

Rinse your paper on both sides, using cool water. You can rinse paper in a sink, bathtub, or by holding it under a shower. Do not soak your paper; just make sure it's completely wet.

When the paper has lost its shine, that's your signal that all the water has been absorbed; none remains on the surface. The paper has now expanded to its maximum size and is ready to be stapled. Gently smooth out the sheet and start your stapling at the middle of an edge. Using 5/16" (8 mm) staples (or a similar size), place staples about two inches apart, set in about a quarter-inch from the edge of the sheet around all four sides. Bulldog clips or pushpins are best suited only for anchoring paper that does not need to be stretched, such as papers that are 300-lb. weight or are small (5 × 7" or less) in size. To avoid having to carry a heavy staple gun when painting on location, I stretch my paper in advance. Doing so also guarantees that my paper is flat and completely dry before I start. Staple corners last and place your paper in a horizontal position until it is completely dry.

To enable your paper to absorb water, lay it on a board. I like to use lightweight, waterproof Gatorboard, which is carried by many art supply shops and catalogues. Gatorboard is an especially good support since staples attach and remove easily from it.

Other Materials

Although painting in watercolor does not require a large assortment of supplies, most artists find the following items necessary. With experience, you will develop your own preferences.

PALETTES

The best watercolor palettes are made of durable white plastic with fitted lids that snap off and on. Select a palette with at least sixteen wells for holding fresh color, and a large mixing area for creating washes. Washes tend to "bead" on a new palette, but after several uses, they will mix more smoothly. Upside-down, the lid also serves as a mixing tray.

Don't worry about letting your colors dry out on the palette. With a little water, the pigment can be rejuvenated. At the end of the day, I like to add six or seven drops of water to each well of color. By morning, the paint has completely softened up again as though it has just been squeezed from the tube.

EASELS

Although having an easel isn't mandatory, working on one does make life easier. I use one of three different kinds, depending on the type of painting at hand. At my drawing table, I use a small, collapsible, upright easel. It holds my painting almost vertically and sits on top of my large drawing table. The small easel allows me to keep my supplies nearby on the table without them rolling off. For painting outdoors or for traveling, I have a lightweight, folding aluminum easel, and for large works painted in my studio, I have a big, wooden, upright floor easel.

MASKING FLUID

Preserving small white areas of the paper while painting in washes can sometimes be difficult, so many watercolorists use masking fluid to block out specific sections. Made of an opaque latex, masking fluid enables you to paint freely over those areas before the mask is removed. But a word of caution: Softer paper may tear if the masking fluid is left on too long. Also, don't use your best brushes for applying masking fluid, since cleaning it off the brush after it has dried can be difficult. To help preserve the brush, I dip it in water and wipe it on a bar of soap before dipping it in the masking fluid.

Most masking fluids will come off your paper by rubbing the area with your finger. A small piece of crepe rubber will also help to remove it.

PURCHASING SUPPLIES

Art materials can be purchased at your local art supply store or ordered through catalogues. The advantage of in-person shopping is the opportunity to select your supplies firsthand. For the beginning watercolorist, it can be especially helpful to look at all the options available and discuss them with knowledgeable sales people, most of whom are artists themselves. But almost all of the materials mentioned in this book are also available through mail order companies such as Art Express (1-800-535-5908), Art Supply Warehouse (1-800-995-6778), and Dick Blick (1-800-447-8192). The only exception is the line of M. Graham watercolors, which are sold only through retail outlets.

LIST OF BASIC SUPPLIES

Brushes
#10 round kolinsky or sable brush
#6 round kolinsky or sable brush
1" to 2" flat wash brush
an old toothbrush for spattering
a small bristle brush for lifting

Paper and Support Board
several sheets of high-quality paper
support board, staple gun, staples

Paints, Minimum Range
new gamboge
Winsor yellow or aureolin
Winsor red or cadmium red
permanent rose
phthalo green or Winsor green
French ultramarine blue
cerulean blue
phthalo blue or Winsor blue
raw sienna
burnt sienna
sepia
Payne's gray

Additional Items
white plastic palette
easel
masking fluid
#2 pencil
soft kneaded eraser (harder erasers can tear or mar paper)
paper towels, sponges
water container

Setting Up a Studio

My first studio was a closet with a window. I was able to touch two opposite walls with my arms outstretched. My next studio was in a former cigar factory. I painted only during the day when there was light. In winter, I used kerosene heaters and wore a hat and gloves while I worked.

Very few artists have the ideal studio. Over the centuries, master artists have worked in damp, candle-lit, drafty spaces and still have been able to turn out magnificent paintings. Their talent and fortitude overcame their meager working conditions. While a spacious, comfortable, well-illuminated studio isn't mandatory, it doesn't hurt, either. Most of us are able to find something in between these two extremes to call our studio.

My present studio is a skylit room over the two-car garage in our house. It has a full bathroom (ideal for stretching paper) and a walk-in closet that's perfect for storing all my extra supplies. Since my bookkeeping, framing, photographing, promoting, and exhibiting are all handled at another location, a modest-size painting space suits me well.

For the watercolor artist, a studio needn't be big unless you plan to work on an exceptionally large scale. A spare bedroom will do. An organized floor plan with consideration for storage is the first step. Tripping over papers, brushes, props, and other supplies can be distracting, if not dangerous, so careful thought about placement and storage of your equipment and supplies is important. I have two drawing tables as well as a couple of cabinets and bookshelves in my studio, all purchased from a retired architect and from various flea markets. In the walk-in closet I also keep my files as well as two large metal cabinets for the storage of more volatile materials such as turpentine and mediums.

I believe the most important ingredient for a functional studio is its lighting. North light is traditionally best for artists, since it stays consistent longer than light coming from the south, east, or west. If you aren't able to have north light or any good natural working light, the next option is to use incandescent full-spectrum lamps. Their pure white light mimics daylight. Sold at lighting supply and hardware stores, the bulbs come in most strengths (60 to 150 watts) and will give your work accurate readings as to color and value contrasts. I use Veriflex full-spectrum lamps on cloudy days or when I am working at night. Their glare-free light is easier on the eyes than standard bulbs.

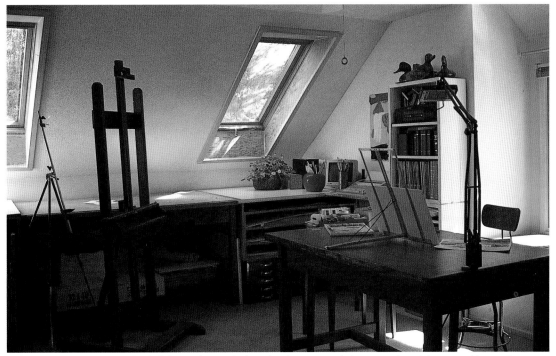

My studio has two low north skylights and one window that faces east. I always work upright on a table easel or at a standing easel. The drawing tables, flat filing cabinet, and bookshelves were all purchased from a retired architect.

Fundamentals

In the years that I've been teaching watercolor and critiquing the work of students, I've discovered that a painting fails for one of two reasons. The first relates to technical problems. For instance, the artist used too small a brush to paint in an area, resulting in patchy-looking washes; or overworked an area too many times, ruining the freshness of the colors; or perhaps stretched the paper improperly, causing it to buckle. These are all technical problems that will be addressed in the chapter "Getting Started" and throughout the book.

The other reason a watercolor painting might fail is because of a drawing problem. Perhaps the artist has no real focal point in the painting, or a certain area of the composition seems to be popping forward because of an incorrect value contrast. Other mistakes students make are trying to use too many colors, having poorly drawn perspective, or selecting incompatible backgrounds.

All of these concerns—concept, composition, drawing, value, and color— are painting fundamentals, the purpose of this chapter and the basis of sound creative expression. As important as technical skills are, they are only mechanics. Without the directives and purpose of fundamentals, technique becomes meaningless. It is like an orchestra without a conductor.

The fundamentals of painting that we'll cover include drawing basics, such as line, shape, perspective, and composition, as well as suggestions for developing strong designs and concepts. A segment on value will take you through the basics of tone, spatial depth, focal points, and the properties of light. Diagrams and explanations about color will give you a better understanding of mixing hues, creating fresh-looking grays, and selecting harmonious color schemes.

Several painting exercises are included as a starting point for your experimentation and growth. I hope they will stimulate you to continue your painting in earnest, finding your own way as a serious watercolor artist.

Mary Whyte
ALPHABET SOUP
Watercolor on paper, 24 × 19"
(61 × 48 cm), 1991. Courtesy of
Salem Graphics, Inc.

This composition is based on the principle of repetition. The round contours of the table, bowls, and cats all help to bring the painting together.

The Importance of Drawing

Drawing is our universal language. It is the foundation of all visual art and is what enables artists of centuries past to speak to us today. Drawing allows us, in turn, to communicate with those around us, as well as with generations to come.

Sound drawing skills are crucial if you are to realize your goals as an artist. No amount of painting technique and gimmicks can cover up a deficit in drawing ability. Without a solid background in drawing, even your best painting ideas will fall short, so draw as often as you can. Your efforts will not go unrewarded, for you're sure to discover much about yourself and the world around you. You'll learn what is important in a composition and what is not, and your newfound knowledge will inspire you to discover still more.

Drawing lets you lay the foundation for the painting process by mapping out the large masses and smaller shapes of your composition. Decisions about placement, size, shape, and direction made in the early stages of a work will allow for fuller and more confident artistic expression as you paint.

Mary Whyte
BOOMER AND BABY BOOMER
Conté crayon on paper, 12 × 22" (31 × 56 cm), 1996. Collection of Smith Coleman.

Drawing the world around you can be like keeping a personal diary. These sketches of our dogs are among my favorites.

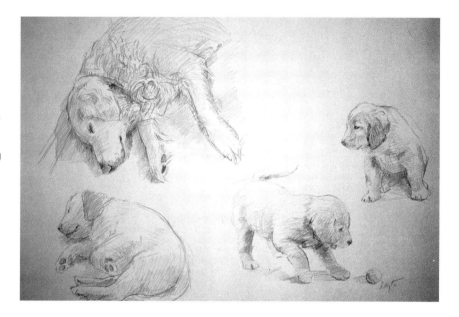

Mary Whyte
STUDY OF HANDS
Conté crayon on paper, 12 × 16" (31 × 41cm), 1990. Private collection.

Studies like this are a good way to explore subject matter before trying to tackle it in watercolor.

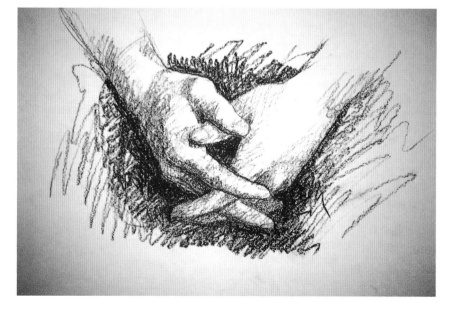

LINE AND SHAPE

One of the first steps on the road to visual expression is learning to see shape. Initially, you must forget about the literal characteristics of an object and see it only as a basic geometric or organic shape. Learning to look past the three-dimensional appearance of an object and see only its shape takes practice. A good way to sharpen those observation skills is by practicing contour drawing, as shown in the exercise below. Being able to see and describe form in its most elementary terms will add a sense of dimension and depth to your work.

It helps to remember that all objects can be reduced to one of four basic volumes: the cube, cylinder, cone, and sphere. For instance, a book and a toaster can be thought of as a cube; a leg, a tree, and a mug are cylinders; a rose bud and a bell are cones; and an apple and an egg are spheres.

Before you begin drawing or painting, study your subject matter's basic shapes. Squint your eye and concentrate on the large, simple masses. Here, the orange is a sphere; the jar, a cylinder. Details are best saved for last.

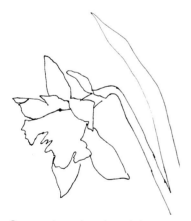

One way to explore shape is by making a contour drawing, which will convey a form's primary visual character. A contour drawing is done by visually following the edges of your subject matter, duplicating what you see with line art on paper.

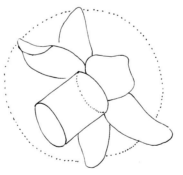

All objects can be reduced to their most basic geometric form. If you can draw a cylinder and a sphere, you can draw a daffodil.

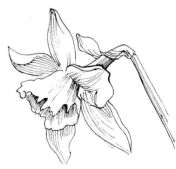

Line drawings convey shape and volume by the direction and the density of line. Adding more lines closer together will suggest shadows or darkness. A heavy line will bring an edge closer or give it weight. Overlapping lines help to give a drawing a sense of depth.

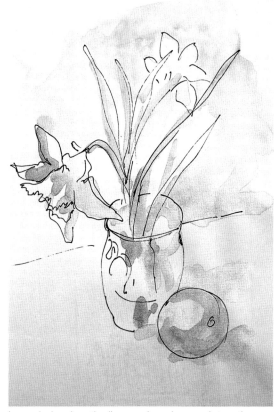

The background area is just as important as the objects in a composition. Strive to make your background shapes and negative patterns as interesting as possible. Too often, beginning artists omit the background altogether. Seeing the background as part of the composition can give your painting more interest and depth. In this drawing, the line behind the still life divides the background and table into two interesting shapes surrounding the flowers.

In wash drawing, the lines and washes work together. Using just one hue of watercolor with varying degrees of water can create a sense of light and dark when added to line. By being able to indicate shadows with washes, a sense of volume can be established quickly.

Mary Whyte
APRIL
Watercolor on paper,
16 × 22" (41 × 56 cm),
1987. Private collection.

Subject matter may often seem complicated at first. Remember that reducing objects to their most basic shapes and volumes makes any painting job easier. When I painted this child's head, for example, I kept in mind the shape of a round ball (a sphere) and how light would play on it. The child's arms reminded me of cylinders. The daffodils are spheres and cylinders turned in different directions.

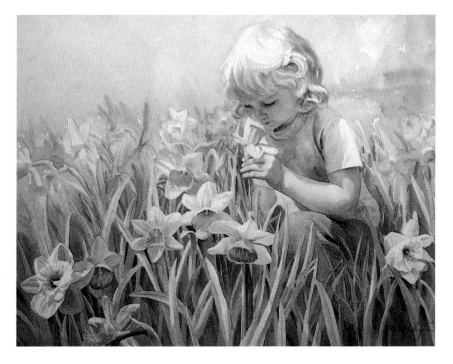

THUMBNAIL SKETCHES

Students quite often show me work that they know has compositional or drawing problems. They will point out all the problem areas of their paintings, and when I ask them how those problems could be resolved, they generally offer viable solutions. The unfortunate part is that they usually discover a problem at the last stage of a painting, at which point any reworking will turn the watercolor to mud. This is really too bad, since the majority of pitfalls in watercolor paintings could have been worked out in advance if only the artists had just taken a few minutes to do a thumbnail sketch.

As its name implies, a thumbnail sketch does not need to be large or detailed. (Mine are usually about 3 × 4".) In fact, details are best omitted, forcing you to concentrate on the largest shapes and value patterns in the composition. A thumbnail sketch is simply a painting road map, planning the distribution of lights and darks and the important elements of design.

If the thumbnail sketch looks good, chances are the finished painting will look good. Sometimes, though, you will find that the thumbnail sketch looks better than the finished painting. The sketch may contain a freshness, vigor, and abstract quality lost in the finished painting. Strive to retain those qualities as you paint, reserving all small and time-consuming details for last.

Be careful, too, that your thumbnail sketch is the same format as your sheet of watercolor paper. A wonderful composition in a square format will not scale up into a rectangle of any size and still work.

A thumbnail sketch will help you to think through your painting in advance by first addressing the concerns of shape, value, and composition. This is the thumbnail sketch I did in preparation for the painting *Springtime*.

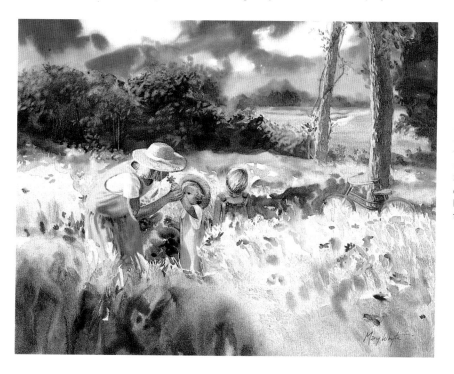

Mary Whyte
SPRINGTIME
Watercolor on paper,
35 × 40" (89 × 102 cm),
1994. Private collection.

Most of the people in my paintings are generous friends who are understanding and good-humored enough to accommodate my requests. My friend Sharon and her two children posed one hot, humid morning for this painting.

SCALING UP AND TRANSFERRING DRAWINGS

Once you have a suitable thumbnail sketch, you'll need to scale up the drawing to fit the larger format of your watercolor paper. The procedure is simple, as illustrated in the series of exercises shown below and opposite.

Many artists find it easier to work out all their drawing problems beforehand in full scale on sketch paper equal in size to the watercolor paper. This saves unnecessary erasing and wear and tear on the watercolor paper. After the drawing is completed, it is transferred to the watercolor paper.

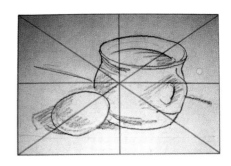

Drawing a grid over your image will help you to execute a scaled-up version in the same proportion. This is the same method that artists used two hundred years ago. Drawing horizontal and vertical lines through an image and then copying it helps the artist to duplicate shapes more accurately.

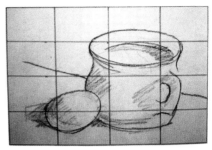

Place your thumbnail sketch on the lower left corner of your watercolor paper. Lay a ruler diagonally across your thumbnail sketch, from corner to corner.

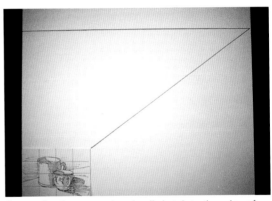

Draw a line from your thumbnail sketch to the edge of your larger paper. Any spot where a vertical and a horizontal line meet along the diagonal will be in perfect proportion to your thumbnail sketch.

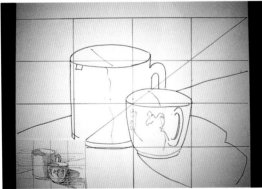

The best way to scale up an image is by making a grid on your thumbnail sketch and then recreating the same proportioned grid on your watercolor paper. By copying one square at a time, an accurate enlarged drawing will appear.

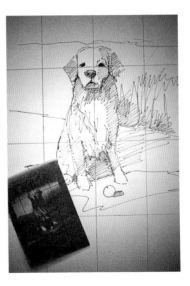

The same method works with scaling up photographs.

Place a sheet of tracing paper over your sketch. Use a soft lead pencil to trace your drawing.

Flip the tracing paper over. Now use the pencil on its side so that you get a fat impression as you trace your lines.

Flip the tracing paper over again and lay it right side up on your stretched and dried watercolor paper. Trace the lines again. The graphite on the reverse side of the tracing paper will lightly transfer to your watercolor paper.

PERSPECTIVE

The geometric system of perspective has been used by artists for centuries. Leonardo da Vinci (1452–1519) and Thomas Eakins (1844–1916), for example, used linear perspective and geometric divisions to work out compositional and drawing concerns. Perspective was and is a systematic means for better draftsmanship.

The two major components of perspective are the horizon line and the vanishing point. The horizon line, generally at eye level, becomes the most distant point. On this line is found the vanishing point, which is not always seen within the picture's format.

As a beginning watercolorist, it may be helpful to structure your drawings with vanishing points. The library will have several useful books written in detail on the subject. After you gain more skill with drawing, it's a matter of being aware that perspective always exists. With experience, drawing with a sense of perspective will come easily.

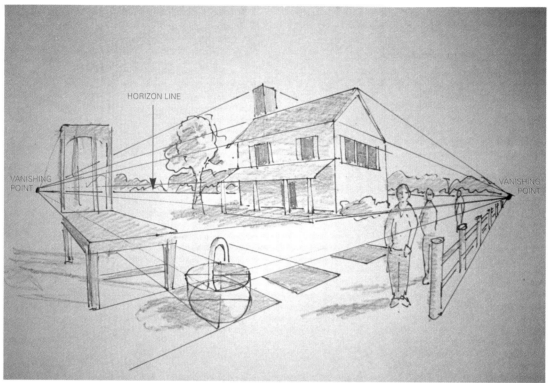

In this diagram showing two-point perspective, the *horizon line* is at eye level. Notice how, for instance, the figures' heads remain at eye level no matter how near or far away they are. Lines that are parallel to the earth are perfectly horizontal at eye level. When those lines are above or below the horizon line, such as the roof or bottom edge of the house and porch, the lines converge at the two *vanishing points*.

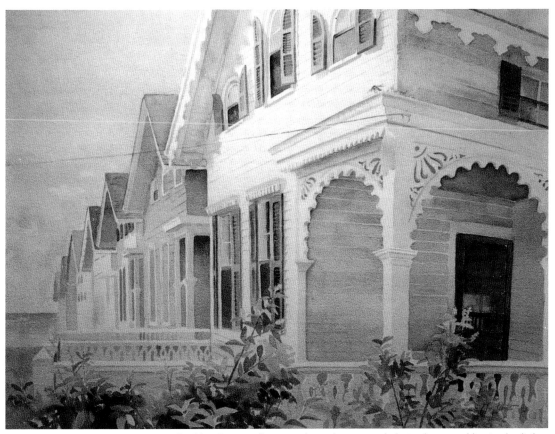

Mary Whyte
CAPE MAY LOOKOUT
Watercolor on paper, 22 × 29"
(56 × 74 cm), 1980. Private collection.

Besides the use of perspective, other means help to give an architectural painting a sense of depth. Sharper focus, greater contrasts, and brighter, warmer colors help to bring objects forward, while grayer, softer shapes and lines recede.

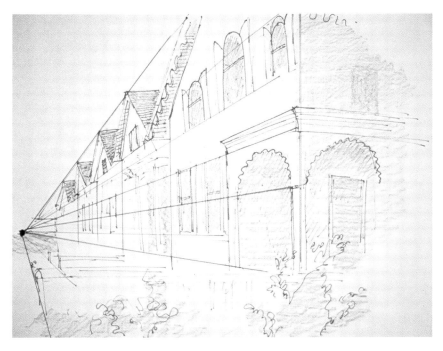

This drawing of an architectural painting shows how perspective is used to make the houses seem to recede into space. Here, I have used two-point perspective with two vanishing points, although one of them is outside the picture plane.

SKETCHING IN WATERCOLOR

The only works of mine that I will not part with are my sketchbook watercolor drawings. These drawings have become a personal diary of many people I have had the good fortune to get to know, as well as the places and objects that have caught my eye.

Your sketchbook is a direct vehicle for sharpening your visual skills and developing ideas for paintings. The drawings can be brief marks or detailed renderings and will help assimilate your thoughts about art. Sketching in watercolor will afford you the added bonus of using color as well as the speed of the medium. Quickly painting washes allows you to cover an area faster than with a drawing implement. Getting to the essence of a subject is easier if one does not labor over superfluous details. For this reason, sketching with watercolor can be advantageous.

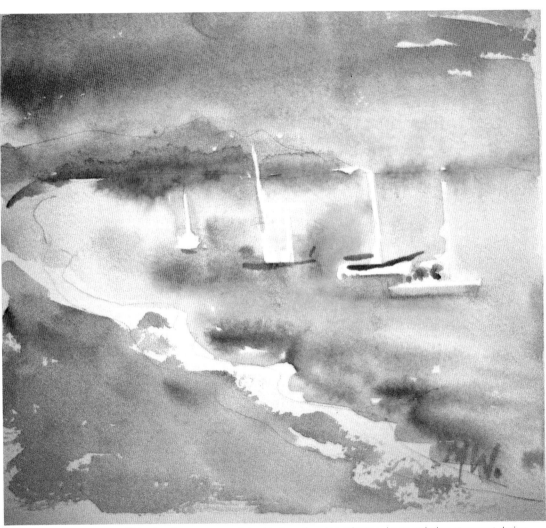

Mary Whyte
CABO SAN LUCAS
Watercolor sketch on paper,
6¼ × 7⅛" (17 × 18 cm),
1994. Private collection.

This sketch was accomplished in less than ten minutes. I was painting at sunset during that fleeting moment when everything turns pink. If I had spent any longer on the painting, I would have ruined it.

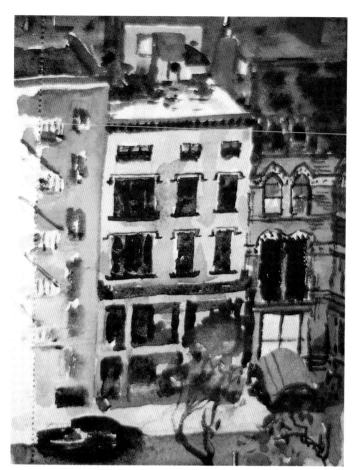

John Falter
GRAMERCY PARK
Watercolor in sketchbook,
6 × 4¹/₂" (16 × 11 cm), 1956.
Private collection.

John Falter (1910–1982), illustrator of more than 185 covers for *The Saturday Evening Post,* was an insatiable observer of the world around him. Many of the ideas for his large, ambitious works were worked out beforehand in sketchbooks. This small, crisp sketch, using an unusual overhead perspective, was painted from the artist's studio windows and became the basis for one of his first *Post* covers.

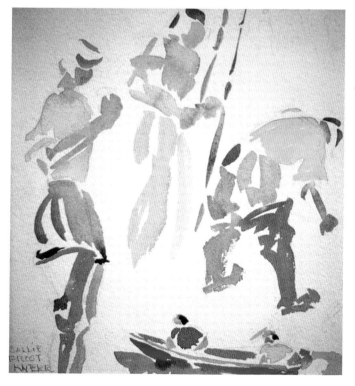

Sallie Frost Knerr
FISHERMEN
Watercolor sketch,
8³/₄ × 8³/₄" (22 × 22 cm), undated.
Private collection.

Sallie Frost Knerr (1914–1988) caught the essence of these figures with simple shapes and few details. Even her arrangement of the figures is pleasing. Figure studies like these can be useful as reference for later paintings. A quick sketch often captures the emotional richness of a moment more effectively than a camera.

Developing a Concept

A student once came to me saying she didn't understand why her paintings, though technically competent, never won any acclaim. She had studied technique with several accomplished instructors and was perplexed that her paintings never received any attention, while others did. After all, she lamented, she painted just like her instructors.

I don't know who is more to blame for this blight on creativity—the student or her teachers. All her efforts to master the watercolor medium were at the expense of her own personal vision. The student had been led to believe that a display of technical dexterity was sufficient for successful artistic expression. She was left with paintings lacking both meaning and concept.

John Falter (1910–1982), a highly successful painter and illustrator, once told me, "Good artists are a dime a dozen. What separates the great ones from the pack is concept." Just what is concept and how do we get it into our paintings? Concept is the notion or idea we wish to express through our work. Concept is not just the subject matter we choose to paint; it is our determination to express a certain point of view.

Much of our predisposition for concept already lies within us. How we look at the world and choose how the world looks at us through our art was set in motion on the day of our birth. Our culture, childhood, relationships, and education combine to make us who we are and give a personal stamp, or style, to our art.

Let us use two famous paintings to illustrate how personal experience translates to concept in art. James McNeill Whistler (1834–1903) made several trips to France and was in close touch with the rising Impressionist movement when he painted his famous *Arrangement in Gray and Black No. 1 (Portrait of the Artist's Mother).* Known popularly as "Whistler's Mother," the painting portrays a woman sitting in profile, as rigid and somber as the austere background behind her. In stark contrast is a painting by Pierre-August Renoir (1841–1919) titled *Madame Henriot,* a gossamerlike confection of colors and brushstrokes depicting a young woman with luscious coral lips and inviting brown eyes that look unabashedly at the viewer. Though contemporaries, Whistler and Renoir could not have had more different concepts of two women.

Serge Hollerbach
CLOUDS AT
MYRTLE BEACH
Watercolor on paper,
7 × 10" (18 × 25 cm),
1990. Courtesy
of the artist.

A painting can be quite simple and still have a strong concept; in this case, a very animated and rich sky above tranquil water. The striking contrast between such round, soft clouds and the flat shape of the marsh makes for a dynamic painting.

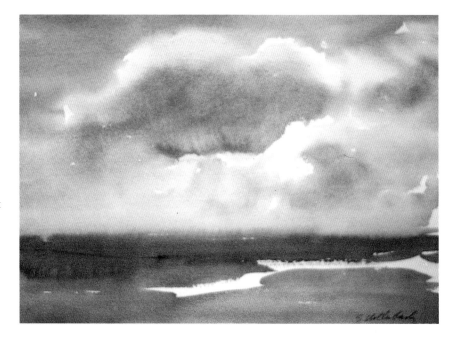

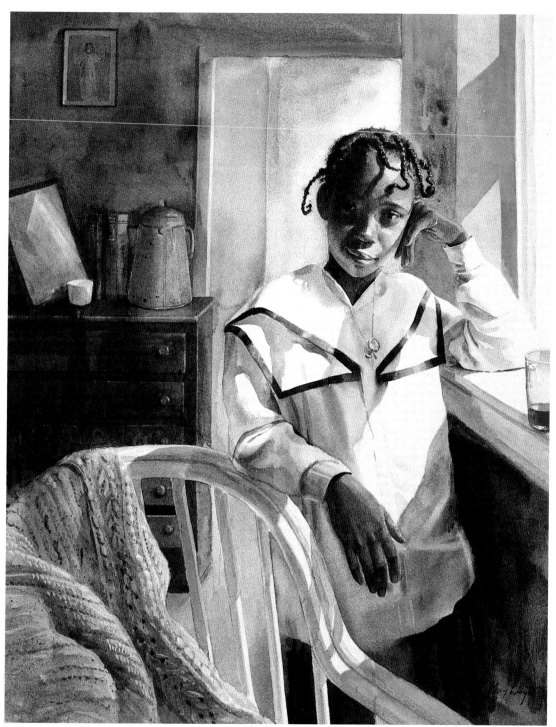

Mary Whyte
SUNDAY
Watercolor on paper,
34 × 30" (87 × 76 cm),
1994. Private collection.

I was completely struck by this model's face and demeanor and wanted to create a painting befitting her age, personality, and background. Everything in the painting is there to strengthen my concept of this young girl. Her youthful oval face is contrasted and framed by the doorway behind her. In spite of her Sunday clothes, I sensed a mischievous quality about her, as portrayed in the tilt of her head, upturned corner of her mouth, and glass of juice teetering on the edge of the windowsill.

Composition

Composition is the studied arrangement of elements. When we speak of composition, we can be referring to the arrangement of notes in a musical score or the arrangement of furniture in a room. It is where we put these things, either by instinct or reason, that ultimately makes a statement about our point of view.

In painting, a worthwhile concept cannot be fully realized without a strong composition. A pear, no matter how perfectly rendered, sitting in the middle of an otherwise empty table is not very exciting. We may admire the technical accomplishment of the artist in the drawing of the pear; however, the image will be neither meaningful nor memorable. But a picture of the pear teetering off-center on the edge of a table will catch our eye, demand our attention, and tell us something about the artist's concept.

Much has been written about composition. Formulas have been made (and broken) by artists for centuries. As early as the first century B.C., the Roman architect Vitruvius was analyzing and writing about composition. Artists realized early on how important composition is in relaying a visual message.

Every *good* painting has only one focal point, or center of interest. There can be a great many interesting shapes or varied subject matter in a painting, but only one area should dominate. If more than one part tries to take center stage, no area will succeed as the focal point. The painting will be fragmented and fall short.

In a rectangular format, our eye tends to gravitate to a certain part of the composition and rest there. One way to determine an area of dominance is by using what some academicians call "The Eye of the Rectangle," a method of dividing up a format into uneven but balanced parts and placing the area of interest in a logical and pleasing position. This is not meant as a hard-and-fast rule; it should be used only as a guide and reminder of the importance of sound composition.

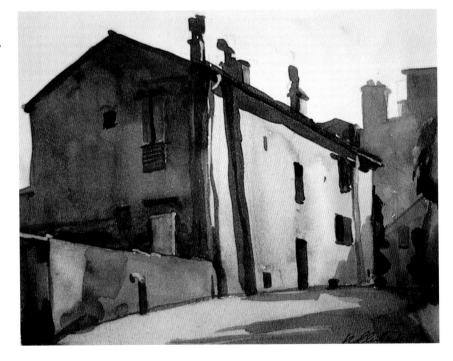

Serge Hollerbach
OLD HOUSE IN FRANCE
Watercolor on paper, 6 × 9"
(16 × 23 cm), 1989.
Courtesy of the artist.

Color is helpful in guiding the eye to the focal point. Note how the carefully placed blue door becomes the center of interest. Place your finger over the blue door and see how lifeless and uninteresting the painting becomes. The small bit of blue activates the warm and neutral colors in the painting. Notice, too, how the shape of the blue door is echoed in the shapes of the windows and chimneys.

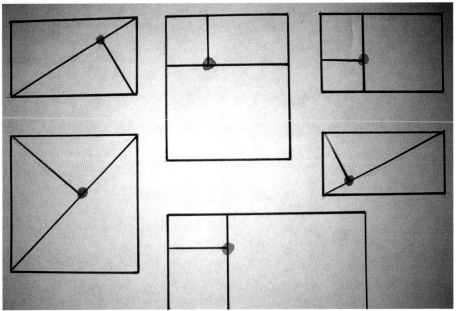

A well-placed center of interest in a composition can heighten any painting's impact. Each dot in these diagrams marks a good spot for you to place your focal point. The diagrams that are intersected horizontally and vertically locate a focal point by dividing the format into one-third and two-third ratios. The other diagrams use a diagonal line drawn between opposite corners, intersected by a line drawn at a 45-degree angle to a third corner. Any horizontal or vertical format can be diagrammed to place a balanced center of interest.

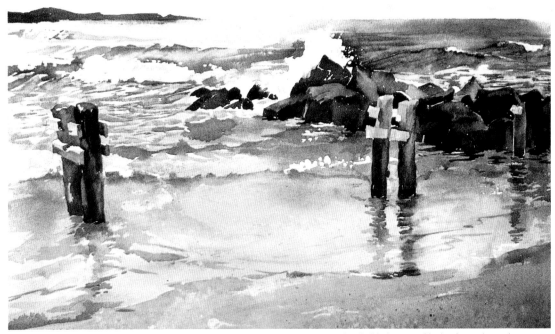

Kass Morin Freeman
OCEAN CITY JETTY
Watercolor on paper,
11 × 14" (28 × 36 cm),
1988. Courtesy of the artist.

This simple but dynamic work evokes an unmistakable impact. Notice how the artist places the center of interest in an area that would correspond with "The Eye of the Rectangle." The pilings and wave in the upper right area continue to draw the eye back again and again. The pilings to the left add a bit of tension and are a good counterbalance to the composition.

How the eye travels through a composition must also be taken into consideration. The viewer needs a path of entry into and through a composition, to be led comfortably to the area of dominance. Interestingly, many compositional designs take on the shape of alphabet letters. For instance, the letters *C, L, Z, J, V,* or *S* can be seen underlying many compositions. While I am certain that most experienced artists are not thinking about letters when composing their paintings, I am sure that simple, strong design is one of their first considerations.

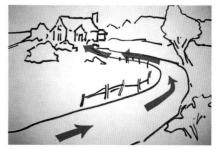

A good composition relies on an efficient design that leads the viewer's eye to the focal point. The winding road is an excellent traditional device for guiding us there.

USING A VIEWFINDER

One of the simplest ways to establish a composition is by looking at a scene through a viewfinder. Particularly helpful in landscape painting, the viewfinder narrows the field of vision to just one contained area. This visual cropping is an aid in omitting surrounding clutter and simplifying the composition. Many artists keep a couple of small viewfinders in their paint boxes at all times. If I need one and am without a ready-made viewfinder at the time, I tear a sheet of paper from my sketchbook, cut a rectangle in the middle of it, and use it for viewing my subject.

You can make your own viewfinder from gray or white cardboard. The opening should correspond to the shape of your paper.

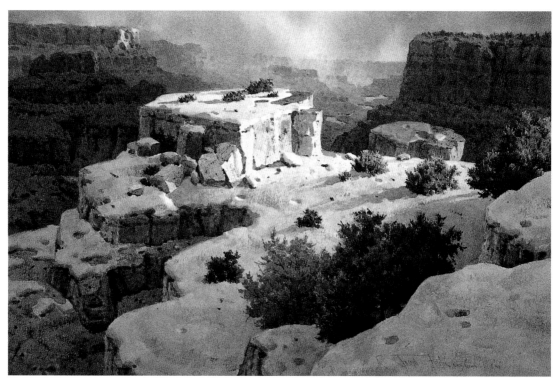

Joseph Bohler
FIRST LIGHT, GRAND CANYON
Watercolor on paper,
29 × 40" (74 × 102 cm), 1996.
Courtesy of the artist.

Diagonals and contrasts lead the viewer's eye to the focal point; skillful use of light and shadow adds interest and drama. Here, the artist leads our eye from lower left to the center, then back diagonally to the upper-left rock formation. The contrast of sunlight on the central focal point projects its impact.

THE EIGHT PRINCIPLES OF DESIGN

Beginning artists are sometimes surprised to learn how much cognitive effort goes into painting. I once gave a day-long art class at a private school for boys, in Philadelphia. I showed slides of my work and did a painting demonstration, explaining all the while the reasons for my painting decisions. At the end of the day, when I asked for questions and comments, a small boy in the back raised his hand and said, "Wow, you really think a lot!"

Good paintings don't just happen. They are the culmination of careful planning, honed technical skills, and diligent effort. As you progress in your art, you will bring to every new painting all that you've learned from previous paintings—your own and the work of others. You'll discover that there is a common denominator among successful paintings, regardless of style or subject matter.

One of the strongest elements enabling artists to convey an idea in a direct or succinct manner is design: the organization of shapes and values so that their various weights balance one another to form a pleasing whole. As previously discussed in this chapter, shape and line are two important aspects of design. Other important elements are value, color, texture, size, and direction. Those elements in varying proportions constitute strong artistic expression and are the foundation of every good painting.

The eight principles of design are how we combine artistic elements (such as shape and line) with psychological values. Alternation, balance, conflict, dominance, gradation, harmony, repetition, and unity are design principles. These elements, our tools for working, are the means by which we can think, plan, build, organize, and communicate with others.

1. **Alternation** is the rhythmical sequence of any design element, such as color, line, or texture. Alternation in color might be the repeated interrelationship of intense and neutral colors. In line, it may be a sequence of straight and curved lines. Texture alternation might be achieved through rough and smooth areas.

2. **Balance** results when opposing forces are equalized. Picture placing different weights of shapes at opposite ends of a seesaw, adjusting them so that they are equalized and balanced.

3. **Conflict** occurs when opposing elements and the tension between them add interest; for example, playing a black square off against a white square, or a circle against a triangle.

4. **Dominance** is achieved through the repetition of an element, such as having more soft textures than hard, more curved lines than straight, or more of one color than another.

5. **Gradation** happens wherever there is a gradual transition, as from dark to light value, warm to cool colors, smooth to rough, vertical to horizontal, and so on.

6. **Harmony** exists when two or more of an item's components are similar. A circle and an oval are more harmonious than a circle and a square; blue and green are more harmonious than blue and orange.

7. **Repetition** is using a particular shape, color, texture, line, or value again and again. It is the design principle that enables the schematic whole to dominate the parts, thus creating unity.

8. **Unity** and harmony are not synonymous. Unity is an integration of parts that make a whole. The parts may differ in size, shape, or color, but none dominates at the expense of others. All parts are interrelated by their careful balance of differences.

Alternation is a rhythmical sequence of opposites, such as big and small, rough and smooth. Here, curved and straight lines are alternated in sequence. Bits of fuzzy watercolor are alternated between hard edges.

Balance happens when opposite or opposing forces are equal, such as a square and a circle, or a large shape balanced by two smaller ones. Here, the green square is balanced by orange and yellow ovals flanking it.

Conflict occurs when you have opposing elements causing tension, such as light and dark, smooth and rough, or straight and curved. The straight lines here are in conflict with the curved lines because they are bunched together like two teams. The conflict of dark and light is accentuated by their high and low positions on the page.

Dominance implies that one characteristic is strongest, such as a specific shape, texture, directional movement, or value. Dominance can be created by having more of one element or in this case, be created by weight. The dark value and hard edge of the blue square, fortified by the shape and edges of the other shapes, help it to easily overrule the expanse of yellow-orange.

Gradation occurs when there is a gradual transition of any kind, such as from light to dark, red to blue, big to little. The transition in these stripes is threefold: from light to dark, from narrow to wide, from green to blue.

Harmony is achieved when any two or more components are similar in any way, such as size, shape, or color. While the shapes differ here, their sizes and pale tones establish harmony in the pattern shown. Harmony is also achieved by the hues' neighborly proximity to each other on the color wheel.

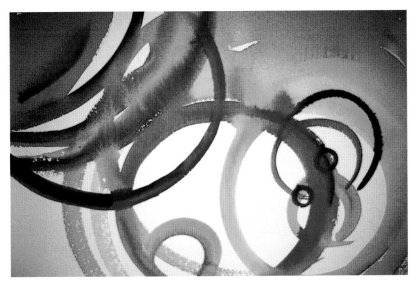

Repetition presents an element of design again and again throughout a composition. It can be shape, such as the circular configurations in this design, or the repeat of a texture or color.

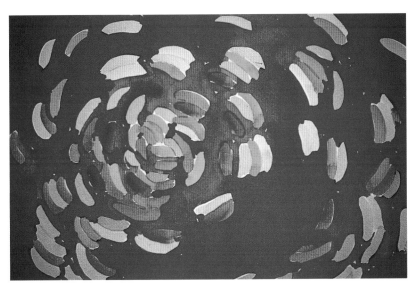

Unity results when all the elements of a composition are cohesive and evenly integrated, each relating to the others. The flat red negative space energizes the clusters of swirling ovals. Although there is a center of interest where the ovals are most dense, the area does not outweigh or become independent from other areas.

Sallie Frost Knerr
UNTITLED
Watercolor on paper,
21 × 28" (53 × 71 cm),
undated. Private collection.

Knerr (1914–1988)
used strong horizontal
shapes in this painting—
a wonderful example
of the design principle
of dominance. Notice,
too, how the artist
contrasted her horizontal
movements with a few
vertical strokes.

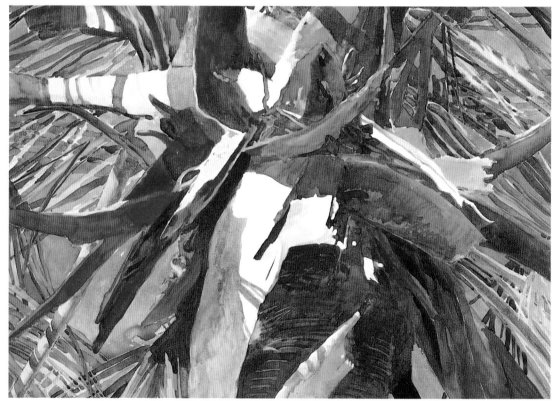

Margaret Petterson
PALM SERIES:
LIGHT PATTERN
Watercolor on paper, 30 × 40"
(76 × 102 cm), 1996.
Courtesy of the artist.

This vibrant watercolor illustrates the principle of unity. All the shapes and colors are interdependent, creating a solid composition. Even the smallest shapes play a fundamental role in balancing and unifying the image.

TIPS FOR BETTER COMPOSITIONS

- Simplify. Don't try putting everything in the picture; keep only essential elements.
- There is no such thing as a bad subject, color, shape, or technique—only one that is in the wrong place.
- Avoid placing the strongest element or area of dominance in the middle of a composition. Having equally sized space around the focal point makes for a static composition, locking the viewer's eye in one place.
- Avoid placing similar objects directly above or below one another, which will make spatial depth confusing. It will look as if the higher object is sitting on top of the other object instead of behind it.
- Avoid placing a key element or dominant shape in a corner. Doing so will lead the viewer's eye out of the painting.
- Remember that every painting can have only one focal point; two or more will battle for attention.
- Always consider the eight principles of design presented above. Remember, it isn't always *what* you say; it's *how* you say it.

Suggested Exercises

1. Make a viewfinder. Practice visually cropping what you see around you.
2. Make six small contour drawings of found objects or groupings in your kitchen. Select the most successful composition, scale it up onto a larger sheet of paper, and create a watercolor painting.
3. Start a sketchbook. Add a watercolor sketch every day until the book is filled.

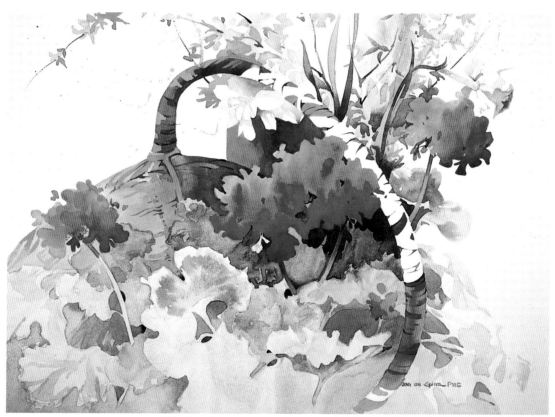

Jean Uhl Spicer
BACK IN SERVICE
Watercolor on paper, 18 × 24"
(46 × 61 cm), 1990.
Courtesy of the artist.

This cheerful but dramatic watercolor achieves its vibrancy through the effective use of white paper. Notice how the basket's handle leads the viewer's eye to the geraniums.

Value

Value is the term that expresses the lightness and darkness of any color relative to the extremes of white and black. Every color and every gradation of it has a value. Between black and white there is an infinite number of gradations, or values. When we say something is high in value, we are saying it is near white; low value refers to darkness.

Had you been born a few hundred years ago and wanted to study painting with a master artist, first you would have had to show your proficiency in using values before you would be allowed to progress to using color. As early as the Renaissance, drawing from casts was considered essential training for artists. Students made drawings of white plaster statues, often turning out literally hundreds of anatomical and other sketches during the course of their studies. Drawing from white plaster casts enabled students to study value closely and to see how it relates to light and form.

Your own study of value will be beneficial to you as an artist. Strong value relationships in your work will give you the illusion of volume, substance, solidity, and spatial dimension far beyond what line alone can do.

It is value relationships that give an image dimension and a sense of place. The visual lightness or darkness we assign to an area will determine whether that object comes forward or moves back in space.

By observing values, we are able to realize an object's volume and surface texture. In short, value is the glue and substance of a sound painting.

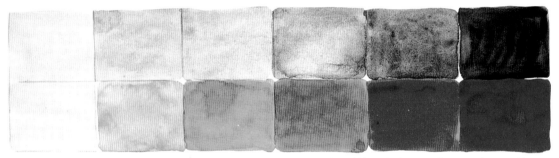

As shown in these light-to-dark scales, every color corresponds to a value. Although they are the same hue, red is darker in value than pink, which is a tint of red.

Each color of watercolor paint straight from the tube is in its darkest value. Most tube colors can be made darker by adding other colors to them, but they cannot be made darker and still retain their purity. Every pure hue has an inherent value. Notice, for instance, how much darker ultramarine blue is than cadmium yellow, as shown in the two value squares.

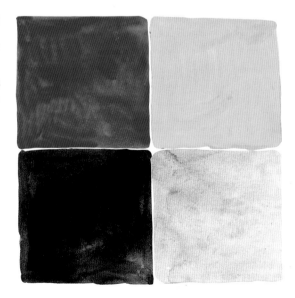

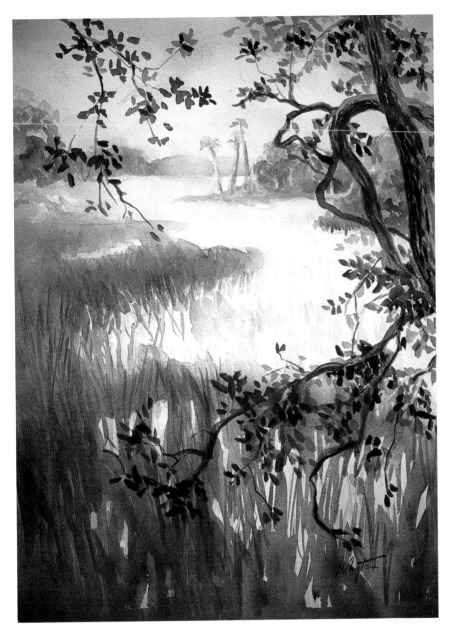

Mary Whyte
MARSH VIEW
Watercolor on paper,
11 × 15" (28 × 38 cm),
1996. Private collection.

This is a view of my backyard. The look changes constantly, with high tide, low tide, sunrise, or dusk, and the quality of the marsh differs seasonally as well. Portraying a sense of distance depends on a successful interpretation of values.

VALUE AND THE ILLUSION OF SPACE

Look at the example of the two dark squares shown at right. Which square appears to be closer? Which one recedes? Both squares are the same size, yet the one with the greatest contrast (the darkest dark against the lightest light) appears to come forward. The other square is not as dark, nor the background as light, so it appears to stay back.

The principle of value contrast and space is fundamental to painting. By giving the objects in the foreground of your painting darker darks and lighter lights than objects in the background, your paintings will have more depth and dimension.

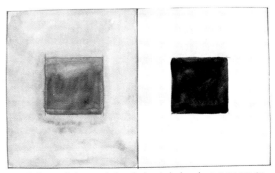

The lightest lights and the darkest darks always seem to come forward. See how the black square against the white background appears closer than the other square?

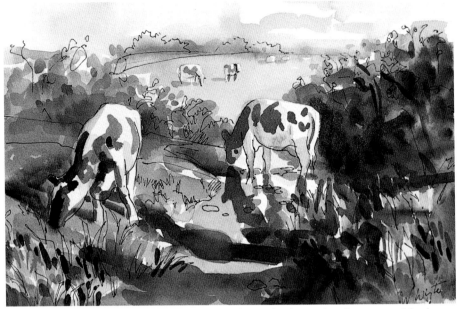

The principle of the darkest dark and the lightest light coming forward applies to everything in nature. On the cow in the foreground, the darkest darks are darker than those on the cow in the middle ground. The darks of the cattle in the distance are lighter still, and their white areas are not as white. The values of the shadows and foliage as they recede are treated with the same principle.

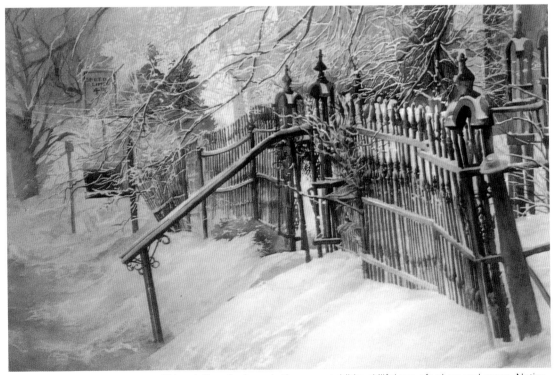

Kass Morin Freeman
SNOW DAY
Watercolor on paper,
26³/₄ × 42" (67 × 107 cm),
1995. Courtesy of the artist.

This painting of a fence in the snow exhibits skillful use of values and space. Notice how the fence and trees become lighter with less contrast as they move into the distance.

VALUE AND COMPOSITION

A good composition boils down to the successful distribution of lights and darks. It doesn't matter what the subject matter is or which style you work in; whether it's abstract or representational painting, both must be based on good composition with strong value relationships.

Arranging lights and darks is a bit like arranging furniture. You wouldn't place all your heavy, dark furniture on one side of the room and all your light pieces on the other. Pieces must be arranged and integrated so that each unit is complemented by the others. There must be harmonious groupings and room to walk. It's a combination of intellectual and intuitive decisions, both made stronger by practice, trial, and error.

How you distribute your lights and darks in a painting can enhance or detract from your focal point. One way to lead the viewer's eye to the area of primary interest is by creating greater contrast there by placing lighter lights next to darker darks.

It's human nature to be visually attracted to contrasts. To give an obvious example, suppose you're at a cocktail party when suddenly, you spill red wine on your white shirt. It's a sure bet that almost everyone will notice. But of course, if you had spilled white wine on the same shirt, few people would ever spot the subtle stain that light liquid would produce on white fabric. Want everyone to notice your new black shoes? Wear white socks (but don't tell anyone I suggested it).

The spot where you place your area of greatest value contrast will automatically fight to become the focal point. Strive to balance your values so that the composition reads well. Study the six examples in black and white shown below to see how value relationships can change the area of interest.

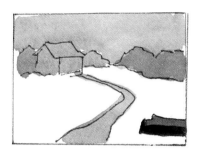
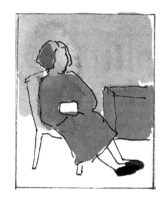

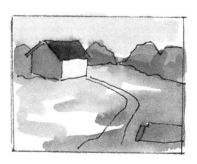
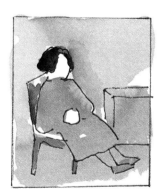
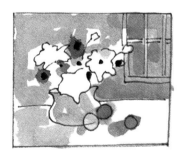

Where you place your area of greatest value contrast will automatically become a focal point. In these pairs of illustrations, it's immediately apparent how the focus shifts from the log to the rooftop in the pair on the left; from the shoes to the woman's hair in the center example; from the window to the flowers in the duo on the right.

Dean Mitchell
SIGN OF THE TIMES
Watercolor on paper,
20 × 30"
(51 × 76 cm), 1992.
Courtesy of the artist.

Squint your eyes so that you see only the light and dark shapes in this painting. Subject matter aside, it is a wonderful combination of lights and darks.

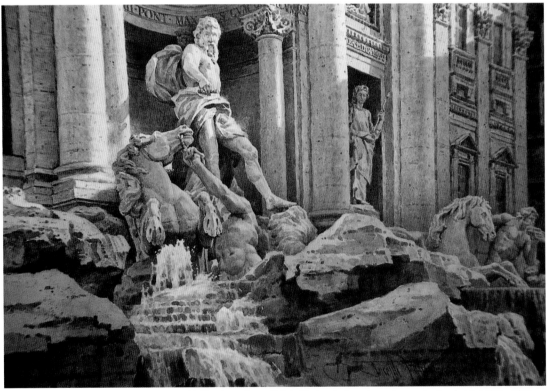

Joseph Bohler
FONTANA DI TREVI—ROMA
Watercolor on paper,
21 1/2 × 29 1/2" (54 × 75 cm), 1995.
Courtesy of the artist.

Notice how the artist deftly leads the viewer's eye to the focal point, using value relationships. The figure of Neptune in the morning light is contrasted against the dark, concave area of the building behind it.

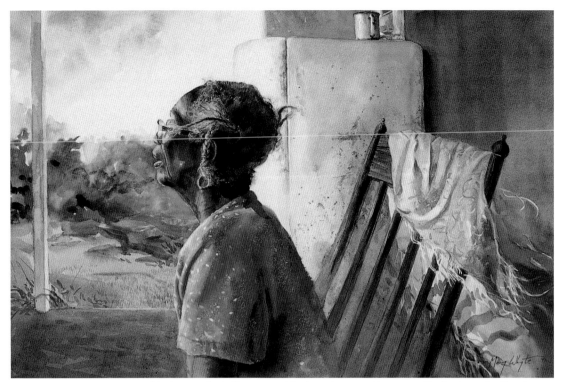

Mary Whyte
SING UNTO THE LORD
A NEW SONG
Watercolor on paper,
26 × 30" (66 × 76 cm), 1994.
Private collection.

Maria was ninety-five years old when she posed for me on the front porch of her home. I asked her to sing her favorite hymn, which she did while I sketched. To emphasize her head, I placed her dark silhouette against the light refrigerator and sky. To suggest a breeze, I invented the airy fringed shawl.

DOMINANT VALUES

Someone once said, "The middle of the road is the worst place to be, especially if you're driving." The same holds true in art, though the consequences for being noncommittal are not as severe as when one is at the wheel of a car. But, in order to make a statement in painting, as in life, you must make a stand on one side of the road or the other. In art, try to say everything and you say nothing. Try to put in every color and none of them will stand out.

Having one value dominate in your painting is an important means for harmonious artistic expression. Instead of equal proportions of lights, middle tones, and darks, one value must dominate. By emphasizing one value, your work will be more cohesive and have more unity. Keeping your painting to one or two fast-reading value patterns will make for a stronger work. As I advised earlier when discussing composition, that caveat bears repeating here: the simpler the better.

An easy way to visualize value is by imagining paint cans. Picture a gallon-size can, a quart-size can, and a pint-size can, each filled with one of the three main values in the painting you're working on. For instance, a workable ratio for your painting would be a gallon of middle tones, a quart of lights, and a pint of darks. Or perhaps it's divided into a gallon of lights, a quart of middle tones, and pint of darks. Your own artistic expression and subject matter will dictate which combination of value weights is best for each painting.

Successful paintings have one value that dominates. Here, a light, middle tone, or dark value dominates in each of the three individual landscapes.

Mary Whyte
OASIS
Watercolor on paper,
27 × 21" (69 × 53 cm), 1992.
Private collection.

Almost all of my close friends have modeled for me at least one time or another. This painting of my friend Carol was posed in the master bathroom of my home. Referring to the "paint can" analogy in my earlier comments about dominant values, this painting has a "gallon" of middle tones, a "quart" of lights, and a "pint" of darks.

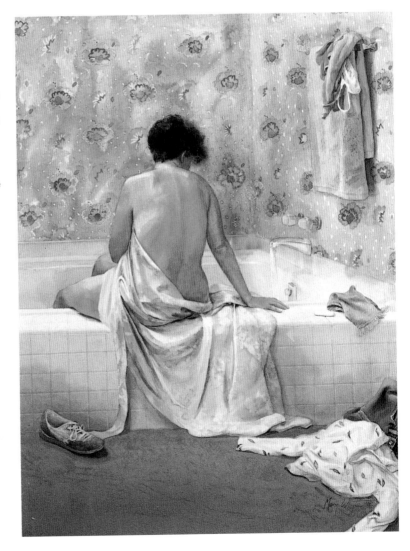

THE SIX DEGREES OF LIGHT

Artists as early as Leonardo da Vinci studied and wrote about the various degrees of light. They understood that every form in its simplest geometric equivalent can be described by different degrees of light.

There are basically six lightings on any object: the light area, the middle-tone area, the shadow side, the cast shadow, the reflected or bounced light, and the highlight.

The lightest area will always be the section precisely at right angles to the source of light. As the plane progressively turns away from the light source, gradually getting darker, we see the middle-tone area. The shadow side is where light rays miss the object altogether. The cast shadow is generally darker than the shadow side of the object, since it receives less reflected light. As the plane continues to turn away from the light source it is affected by bounced light being reflected off nearby planes facing the light. Finally, a highlight, as its name implies, is one or several small spots that receive the greatest amount of illumination on a surface. To keep these points in mind, refer to the following summary:

1. Light area: planes directly facing the light source.
2. Middle area: the area between the light and shadow area, receiving only partial light.
3. Dark, or shadow area: the planes completely missed by the light source.
4. Cast shadow: always darker than the shadow side of the object.
5. Reflected light: caused by light bouncing off nearby objects; never as light as the first light.
6. Highlight: the very brightest point of illumination on an object located within the light area.

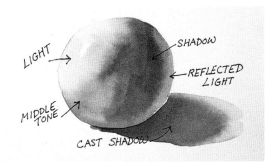

There are six degrees of light that affect objects.

DIFFERENT LIGHTING EFFECTS

The effect of light in a painting can add drama and intensity far beyond what subject matter alone will give it. Too often, beginning artists settle for the lighting situation at hand, ending up with lackluster work. But a little imagination and preplanning can go a long way to insure a strong work of art.

Traditionally, artists have always favored painting by north light, the most consistent lighting in a studio situation. Generally cool, north light will remain the same for more hours, giving artists a longer, more consistent painting day. Under north light colors are truer and the shadows are softer.

Painting outdoors under natural sunlight is always exciting, particularly early or late in the day when the light is warmer and the shadows are long and cool. Cloudy days offer a light much like north light, with different diffused light bouncing off clouds in several directions.

A strong single source of light coming from the side is always dramatic. When the subject matter is presented so that it's half in light and half in shadow, objects will appear in places lighter or darker against the same background. Lost and found edges start happening, and the painting is apt to achieve vibrancy from strong value contrasts. Side lighting can be achieved by positioning yourself so that the sun is coming from your right or left.

Back lighting is often overlooked by beginning artists. Objects lit from behind often are "haloed" with light. All the shapes on the forward shadow side are close in low value, making for sensual and sometimes mystical results.

Generally speaking, the less common the light source, the more interesting the results are apt to be. Edgar Degas (1834–1917) was one of the first artists to employ the use of "up lighting" in his paintings of ballerinas and opera singers. Duplicating the theater's spotlights pointing upward onto figures onstage, Degas was able to add a riveting quality to his works.

An option for painting still life is the use of a shadow box. A special box for still-life setups, it uses narrow bands of light, highlighting specific objects. (For more about shadow boxes, see chapter 4, "Still Life.")

Mary Whyte
THE MARSH AT DUSK
Watercolor on paper,
7 × 10" (18 × 25 cm), 1996.
Collection of Mr. and Mrs.
Barry J. Poupore.

Dusk creates a light
very similar to north
light. After the sun goes
down, the remaining
glow is created from
the light bouncing
off clouds. As in this
painting, the colors
are less intense and
closer in value.

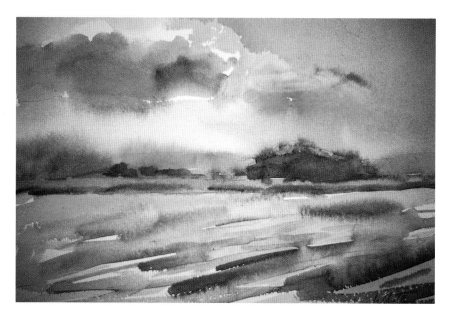

Mary Whyte
EBB TIDE
Watercolor on paper,
23 × 19" (58 × 48 cm),
1991. Private collection.

Side lighting places
subject matter in half
light, half shadow.
I had this model pose
at the same time each
morning, so the light
would be consistent.
When she was taking
breaks or wasn't there
at all, I painted the
linens and other objects
in the composition.
With the model's head
turned away, the viewer
tends to focus on the
many textures and
shapes of the setting.

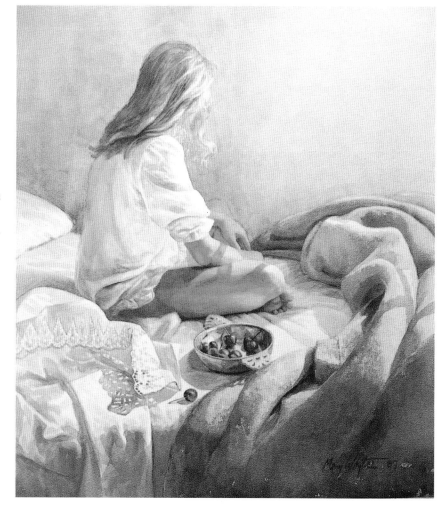

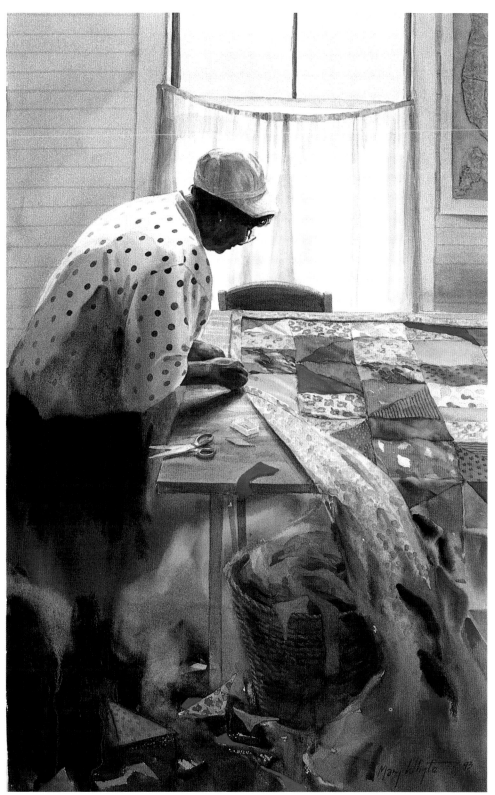

Mary Whyte
A PATCH OF LIGHT
Watercolor, 28 × 18"
(71 × 46 cm), 1995. Collection
of Evagrio Sanchez.

This is one of several women from a local church who get together once a week to make quilts and socialize. The back lighting coming from the window emphasizes the shape of the figure's head and bent torso. The crisp, hard edges and bright colors of the fabric contrast with the soft gray areas of the painting.

Suggested Exercises

1. Using Payne's gray or raw umber, do three small paintings of views from your windows.
2. Paint three versions of the same still life: using side light; using back light; using north, or diffused light.
3. Make two paintings of a still life, using no more than three objects. Paint the still life using only one color. Then paint the same still life using all the colors you see, but making all the colors the same middle value. This painting will have no value contrast and, if photographed in black and white, would appear as an even gray tone.

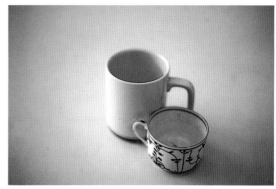

When working from a predominantly single light source—in this case, coming in from the left— any variation in value is caused by the angle at which light rays hit the form. The more an angle is turned toward the light source, the lighter in value it will be.

Because watercolor is generally worked from light to dark, the lightest values are painted first. The lighter the value, the more water is mixed into the wash. First I stretched a sheet of Arches 140-lb. cold-pressed paper. After it was dry, I sketched in the basic shapes, using a #2 pencil. Then I wet the area of the cups and charged in the wash on the shadow side. Working wet-into-wet like this will always produce a soft edge.

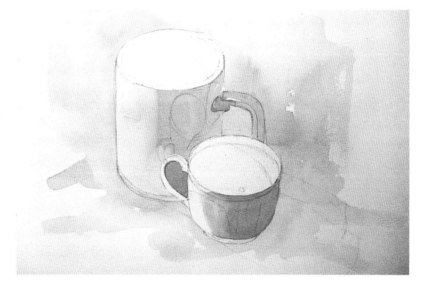

Learning to see value relationships means divorcing yourself from the literal and decorative characteristics of an object. Instead, squint your eyes and look for the large shapes and general value patterns. Here, I restated the contours of the cups by applying another darker wash. I painted the cast shadow on the inside of the forward cup, carefully leaving the white highlights in the bottom of the cup.

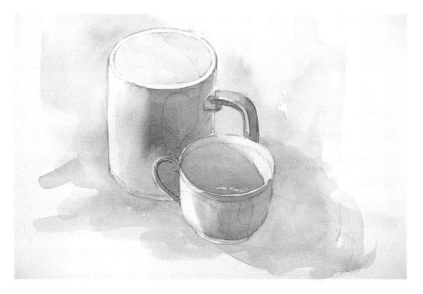

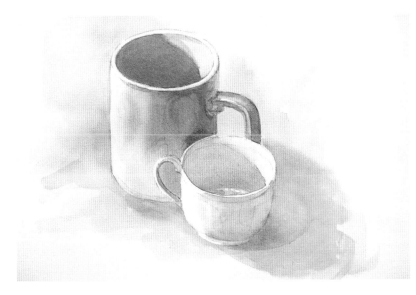

I worked on the cast shadow of the cup in the rear. Then I darkened the cast shadows, so that the one to the right of the cup is now darker than the cup.

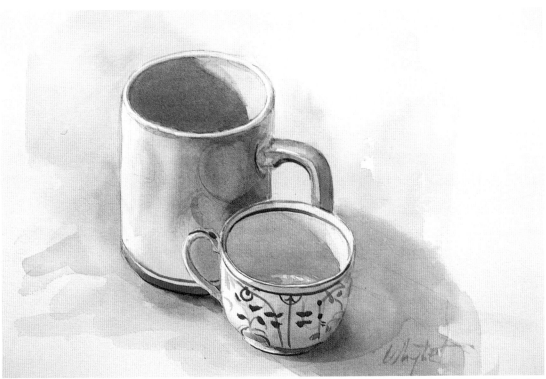

Mary Whyte
TWO CUPS
Watercolor on paper,
9 × 12" (23 × 31 cm), 1996.
Collection of Jane Lewis.

As always, the darkest areas and any decorative pattern areas are best saved for last. Strive to describe the form first in all that you paint. Here, I used a #0 brush to get the thin, calligraphic decoration on the cup.

Color

Color is the emotion and magic of painting. Its innate power has the ability to shape our moods and influence our senses, ultimately bringing us closer to the painter's intention. The response we get from viewing a pure blue next to orange is altogether different from what we may feel when viewing an earth color next to a cool gray. A landscape painted with intense reds, yellows, and blues projects a different feeling from one painted in shades of violet. A portrait painted with true skin color will present the model's character one way, while a portrait painted in hot, contrasting colors will convey a stronger, more assertive personality.

In music, there is no such thing as a bad note, only a note in the wrong place. The same holds true in art. As with shape, texture, or line, there is no such thing as a bad color. It is the proximity and proportion of colors to one another—in other words, their interrelationships—that determine their conceptual and emotional impact. Beauty is simply a question of relationships and how we as artists orchestrate them.

Painting with color is part knowledge of theory and part instinct. Many of your color decisions will be made intuitively, giving rise to confidence as you gain experience. The undisciplined use of color will result in a fragmented composition. Any knowledge you can garner about color and its properties will only widen your vocabulary and strengthen your voice as an artist.

Mary Whyte
QUEEN
Watercolor on paper, 26 × 20"
(66 × 51 cm), 1992. Collection of
Mr. and Mrs. Robert Cline.

The women of the local senior citizens' center meet on Wednesdays for worship, fellowship, and to make quilts out of donated scraps of fabric. Maria, who was in her nineties, had made hundreds of quilts in her lifetime and was for many years the matriarch of the group. The rich, regal colors I chose for the painting seemed appropriate for projecting a feeling of dignity and stature. Working on Arches 140-lb. cold-pressed paper, I quickly established the foreground wet-into-wet, painting around jagged white shapes. After the initial washes were dry, I went back and carefully painted the quilt patterns inside the white shapes, using a #10 round kolinsky brush.

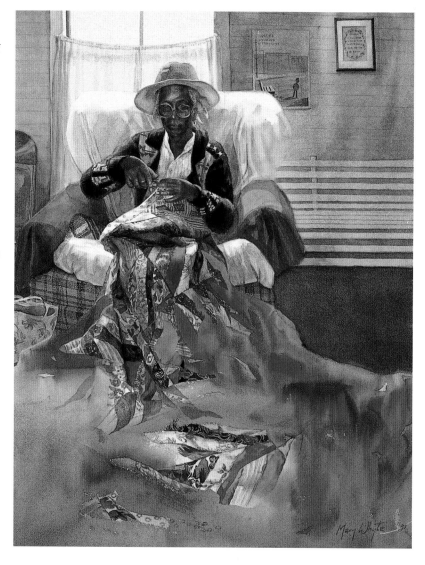

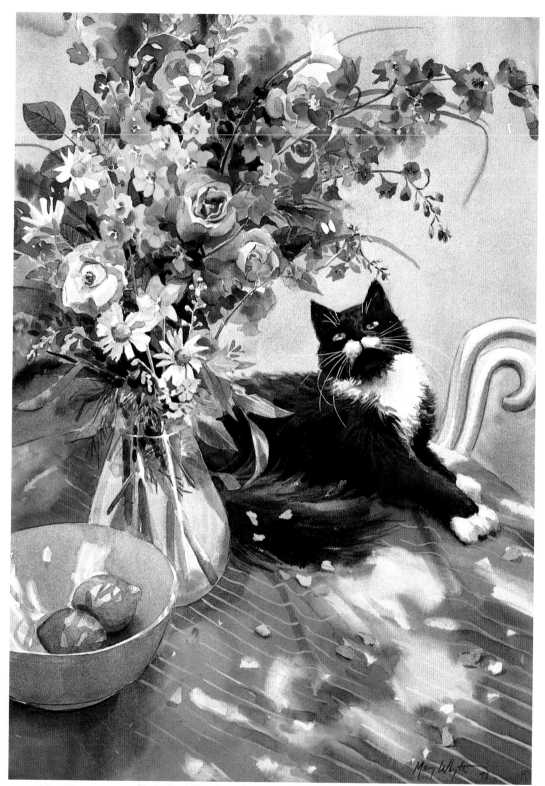

Mary Whyte
SPRING BOUQUET
Watercolor on paper,
26 × 19" (66 × 48 cm),
1995. Collection of Mr. and
Mrs. Robert Applegate.

Black should be viewed as more of a color than a darkening agent. Though I use Payne's gray a good deal, I almost never use it by itself, since I am concerned it will be drab and lack interest. If you look closely at the black cat, you'll see other colors in its fur. Working on Arches 140-lb. cold-pressed paper, I painted from life, but used reference photographs for the cat. I added its whiskers and the tablecloth stripes last, using white gouache.

THE COLOR WHEEL

The color wheel is an ordered arrangement of hues from the spectrum, placed in a circle. A total of twelve hues are all built around the three primary colors: red, yellow, and blue. All the other hues are derived from these three colors, yet the three primary colors cannot be mixed from any other colors, since they are already in their purest form.

Halfway between the primary colors on the color wheel are the secondary colors: orange, green, and violet. These colors are created by mixing their two adjacent primary colors. Last are the six tertiary colors: red-violet, blue-violet, blue-green, yellow-green, yellow-orange, and red-orange. Colors such as brown and gray are a mixture of various colors on the color wheel with their complements—complements being any two colors that lie directly opposite each other on the color wheel, such as red and green.

THE PROPERTIES OF COLOR

When you are working on a painting and trying to decide what color to make a certain passage, you are not making one decision; you are making four. Many beginning artists falsely believe that the only decision they need to make is *hue,* or which of the twelve colors from the color wheel they will select. Hue is simply the color's common name, such as blue-violet or orange.

Value is how light or how dark a color is. Red is the same hue as pink, but is darker in value. A pure yellow is lighter in value than a pure blue. Most watercolorists work from light to dark, decreasing the amount of water in their color mixtures as they go along, hence making darker washes. Value is relatively easy to adjust and correct in watercolor. If the wash you have put down is too light in value, simply glaze over it with another wash until you have the desired value. If the wash is too dark, you can correct it by immediately adding clear water to it or by quickly blotting it with a paper towel, which will lighten the value. If the wash area has already dried, you can lightly scrub and lift the area with a sponge or brush, providing it is not a staining color.

In his experiments on light, Sir Isaac Newton (1642–1727) used the prism to break white light into colors of the spectrum and recombine the colors to form white light. Bending the colors of the spectrum into a circle creates the color wheel, made up of twelve hues, all built around the three primary colors: red, yellow, and blue. From these hues all colors and their variations can be mixed.

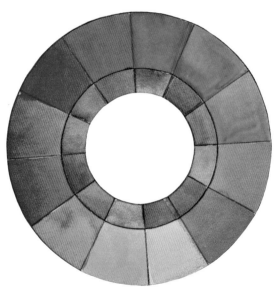

A color wheel can be created using colors directly from the tube and placed in logical order. This color wheel is made up of cadmium yellow, gamboge, cadmium orange, cadmium red light, cadmium red, permanent rose, dioxazine purple, French ultramarine, cobalt blue, cerulean, Winsor green, and sap green.

The colors on the inside band have been glazed with their complementary color. Complementary colors are always found opposite of each other on the color wheel. Using a color's complement in this way will produce a variety of interesting grays.

These two bands of color illustrate the difference between value and intensity. The band on the left moves from a dark value to a light value of the same hue. The band on the right is all the same value, but moves from a gray to a more intense color.

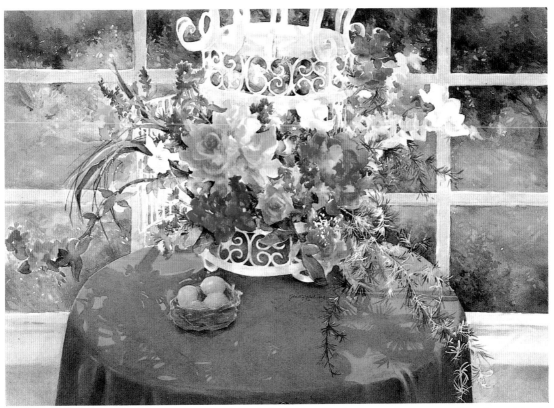

Janet Walsh
CAGED BEAUTY
Watercolor on paper,
29 × 40" (74 × 102 cm),
1996. Courtesy of the artist.

The dominant hue in this painting is blue. The liveliness of color comes from the variety of clean blues and blue-greens as well as blue-violets. Notice how the background also has blue in it, but not enough in quantity or intensity to steal from the beauty of the objects in the foreground.

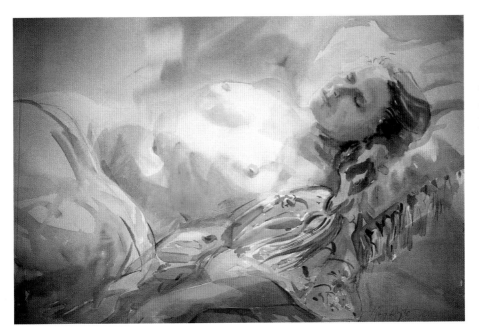

Mary Whyte
SLEEPING
Watercolor on paper, 21 × 27" (53 × 69 cm), 1995. Private collection.

The quiet feel of this painting comes largely from its overall light values, except near the head, which is the focal point. I created this painting from life as a class demonstration, using Arches 140-lb. cold-pressed paper that had been prestretched. Most of the painting was worked wet-into-wet in order to achieve the soft, dreamlike edges.

Chroma, or intensity, relates to how pure a color is. The purer a color is, the more intense it will be. Students often confuse value with chroma, thinking that if they add white to the color, it will make it more intense. The opposite is true. The instant you add anything to a color, white, black, or another color, you are diluting the hue and making it less pure. Watercolor is actually a subtractive process. The more you add to a color, the less intense it becomes.

In nature, intensity is affected by proximity and by the degree of light. The closer an object is to you, the more intense the color will be. In the distance, objects will become less intense in color and actually move toward their complement or gray. Lighting also has a profound effect on intensity. The more light on an object, the more intense its color will be. Sunlight will produce more vibrant colors than you will see on an overcast day or at night.

The last aspect of color you need to understand is *temperature.* Temperature indicates how warm or cool a color is. On the color wheel, every color moves toward yellow or toward blue. Colors with more blue in them are considered cool, while colors that contain yellow are called warm.

Color temperature is often confusing for inexperienced artists. Beginning students sometimes mistakenly believe that all blues are cool and all yellows are warm, or that certain colors are always one or the other. In truth, color can be manipulated to look either warm or cool by its relationship to an adjacent color or colors.

In painting, structure and depth can be created with color temperature. Objects in the foreground can be made to look closer by giving them warmer colors. Objects can be made to recede by utilizing cool colors. The best living example of this is autumn in the mountains. The trees in the foreground will be brilliant yellows and reds, while the same variety of trees will appear a blue-violet in the distant mountains.

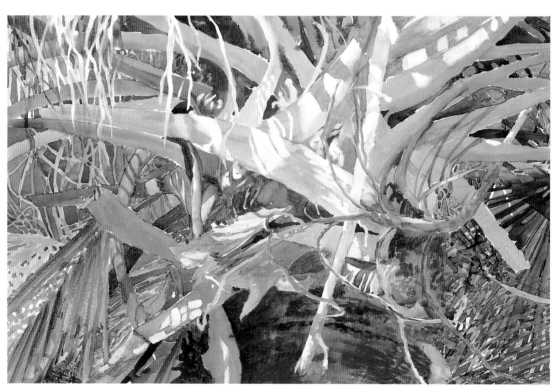

Margaret Petterson
PALM SERIES: JEWEL TONE I
Watercolor on paper, 24 × 36"
(61 × 91 cm), 1993. Courtesy of
the artist.

The use of strong chroma and dynamic shapes contributes to the success of this painting. Look at how the artist plays up her strong oranges and reds by contrasting them with their complementary blue-violet.

Study this illustration of three red boxes. Is the red box in the middle a warm or cool red? Place your hand over the box on the left. Of the two remaining boxes, the box in the middle appears warm. Now place your hand over the box on the right. In contrast to the other box, the red box in the middle now appears cool.

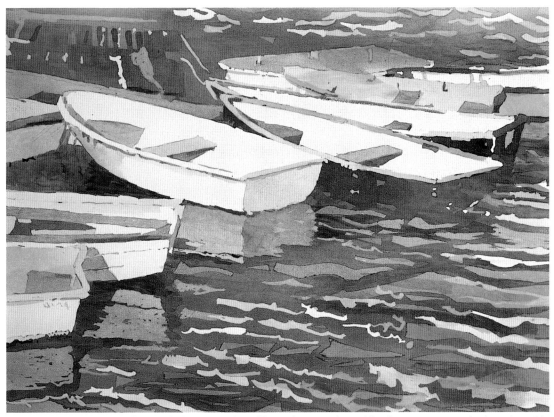

Judi Betts
ON THE WATER
Watercolor on paper,
22 × 30" (56 × 76 cm),
1995. Courtesy of the artist.

The rhythmic progression of boat shapes and transition from warm to cool colors gives this painting interest. Spatial distance is created by color temperature. Notice how the artist paints the water in the foreground with warm colors and the water in the background with cool colors. The boats are painted with a mixture of the same warm and cool colors, giving the painting unity.

MIXING COLOR

To begin with, mixing color will be a lot easier if you set up your palette like the color wheel. I like to put my yellows and reds on the same side, my greens and blues and violets on another side, and my earth colors and black on the third side. How you set up your palette is entirely up to you, but arranging your colors in an orderly fashion will speed up painting time by freeing you from having to hunt for a certain color on your palette.

When combining two or more colors, try not to overmix. Your paintings will appear brighter and livelier if you let the colors blend themselves optically on the paper rather than overmixing them on the palette. Adjusting color too much after you have put it on the paper can lead to disappointing results. After you have painted an area, leave it alone and try to analyze the color's accuracy. Keeping in mind that watercolor always dries a bit lighter and less brilliant than it looks when it is wet, you may need to intensify and darken your color mixtures a bit. Adding too much water to your mixtures will make your color lack richness. Note which colors blend well with others and which don't. Getting to know the right ratio of water and pigment, as well as the nuances of color mixing, simply takes practice. To avoid having too much water in my washes, I first wet or rinse my brush in water. Then I lightly touch the brush tip to a paper towel before touching the paint or mixing the wash.

When painting something that is predominantly one color, it may be helpful to mix a large puddle of the closest hue first. Then by adding warmer and cooler versions to that base color as you progress, your end result will have more variety and interest.

GRAYS

Often students are told by their teachers never to use black. Cautioned that their works will become muddy, students are advised to use other colors instead. While it is true that using black will dull a color, it can also be used successfully. Consider the works of many of the old masters or the Impressionists. Édouard Manet (1832–1883) called black the "queen" of color. The way John Singer Sargent (1856–1925) used black was stunning. Then why are black and gray so difficult to use?

It's not a matter of whether or not you should use black, but of how to use it. If you think of black only for darkening or graying a color, then you will probably end up with something close to mud. But if you think of black or gray as a beautiful, neutral color, then it will lend strength and interest to your work.

I keep Payne's gray on my palette, but rarely use it by itself. Instead, I use it mixed with a bit of another rich color to get some of my darkest neutrals. Mixing ultramarine blue, raw umber, or Winsor green into Payne's gray can produce some velvety, saturated, and interesting darks, much more appealing than using Payne's gray or another gray or black by itself.

Grays are best mixed using complementary colors. Any two colors opposite each other on the color wheel will produce a different type of gray when mixed together. The important thing to remember here is that the gray you end up with depends on the proportions of the colors used. In other words, a mixture of alizarin crimson and Hooker's green will produce a reddish gray if more alizarin is used. The gray will appear more green if the latter color is used more heavily in the mixture.

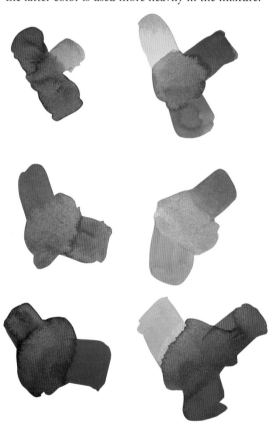

You can make a wide variety of interesting grays by mixing complements or versions of the three primary colors. The gray can be manipulated to appear warm or cool by the proportions of the hues in its mixture. Illustrated are six different grays and their components. Many more grays can be created using different combinations on your palette. *Top left:* permanent rose, raw sienna, Winsor green. *Top right:* cadmium yellow light, permanent rose, phthalo blue. *Center left:* ultramarine blue, burnt sienna. *Center right:* cerulean, cadmium orange. *Bottom left:* sap green, cadmium red light. *Bottom right:* gamboge, cadmium red, Winsor blue.

ANALOGOUS COLOR

Analogous colors are those that are contiguous on the color wheel and have one primary hue in common. If you study the works of master painters, you will notice that each of their paintings has a predominant color feel or identity to it. The Impressionists' paintings were predominantly blues and greens, while the painters of the Renaissance emphasized oranges and reds. There was a reason for that. The artists understood that certain color relationships and their proportions were harmonious while other color combinations created discord.

Using analogous color schemes will give your work color unity. This means that your painting will have a dominant color feeling punctuated by smaller proportions of the color's complement and sometimes a discord, which is a color that is neither analogous or complementary. The neutral colors created by mixing the dominant colors with their complements are very important, because they help to give the other colors brilliance. Neutrals also give the eye a resting place and create a visual "bridge" between the dominant hues and their complement.

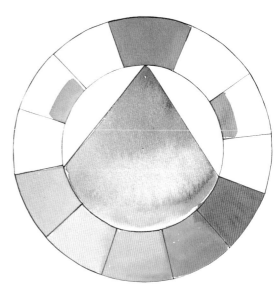

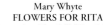

This partial color wheel shows the analogous color scheme I used for *Flowers for Rita*. Most of the colors in the painting range from orange to yellow-green, and are heightened by yellow-orange's complementary color, blue-violet. The central triangle contains the range of neutral colors. The strips of red-violet and blue-green are discords, used in very small, but equal parts of the painting.

Mary Whyte
FLOWERS FOR RITA
Watercolor, 20 × 14" (51 × 36 cm),
1996. Private collection.

Painted on Winsor & Newton 140-lb. rough paper, the dominant hue in this painting is orange-yellow, together with its analogous colors, yellow, orange, yellow-green, and orange-red, accentuated by complementary blue-violet. These fast-fading flowers had just been picked from my garden, so I had to complete the picture in one session while they were still fresh.

DIRECTING ATTENTION WITH COLOR

The way you use color can direct the viewer's eye to certain areas of your painting. With this in mind, one way of establishing a section of interest or focal point is by giving one particular area your most vivid color, keeping all other colors either complementary or neutral. In the painting *Pears and Pussywillows* below, the most intense color is at the focal point, the pears.

Because of the pears' clarity and color intensity, the eye keeps returning to them. But a focal point's color doesn't have to be vivid to draw the eye. Sometimes the color can be subtle and still garner interest because it is different from or complementary to the majority of colors used in the painting, as in *Queen* (page 54), where the model's orchid-colored hat is in contrast to all the other colors in the image.

Jeanne Dobie
AEGEAN SHADOWS
Watercolor on paper,
22 × 30" (56 × 76 cm),
1993. Courtesy of the artist.

Here is a wonderful example of a little color going a long way. By leaving her paper white in large areas, this artist unified her painting and helped all the other colors in it to appear livelier. The beautiful sparkling whites are emphasized by their contrast to the blue sky and blue-green water. All the larger shapes create a resting place for the eye and serve as a backdrop for the smaller, darker shapes of the windows and foliage.

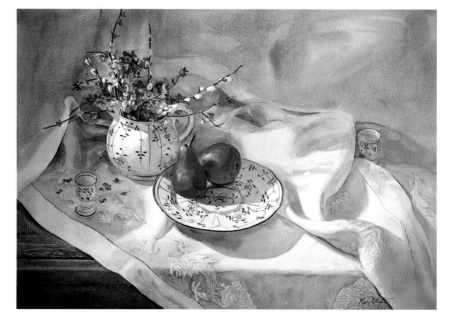

Mary Whyte
PEARS AND PUSSYWILLOWS
Watercolor on paper,
20 × 26" (51 × 66 cm),
1996. Courtesy of the New York Graphic Society.

A still-life box was useful in lighting this still life. I cut a hole in the left side of the box and trained a spotlight through it, so that only the pears and a bit of the other objects were illuminated. By receiving more light than the rest of the still life, the pears were more intense by comparison. I used a #40 round sable brush for the background, smaller brushes for foreground objects, and a #8 round kolinsky brush for details.

BACKGROUNDS

Many artists mistakenly view the background as one of the least interesting aspects of a painting. They often neglect that area or, at best, treat it halfheartedly. Yet the background can affect our perception of a subject in so many ways that it is remarkable how little attention is paid to that space. Simply put, a background can make or break a painting.

A painting's background can say a lot about its focal point. For example, let's say we're painting a lush red apple. In the background, we include items and colors that echo and complement the idea of "lush." If, instead, the apple is brown and decaying, the background will reflect this, even though the setting is precisely the same in each case. The background should help lead the viewer's eye to the focal point. Nothing in the background should be more important than the focal point.

My students frequently ask, "What color should I make the background?" In turn, I usually ask the students, "What do you want the painting to say? What colors will enhance the focal point?" Very often students think they should select a color that hasn't been used yet in the painting, or a color they think is "pretty." The result is often disastrous.

A better idea is to mix two colors that appear in the foreground in order to create a harmonious background color. For instance, if the model is wearing a blue shirt and a yellow hat, try mixing the blue and the yellow together for a green background that is harmonious. Or if your intention is to play up the yellow hat, try making a complementary violet color for the background. There are no rules for the background, only possibilities.

TIPS FOR MAKING SUCCESSFUL BACKGROUNDS

- Do your homework. Very often the background takes up a large area of a painting. With so much importance given to the background, making preliminary color sketches is always time well spent.
- Start early. We've all made the mistake of waiting until a painting was finished before laying in the background. The result is usually disappointing. Remember, every time you add a brushstroke, you consciously or subconsciously weigh that color against surrounding hues. Establishing the background early allows you to make more accurate and sensitive decisions later.
- Be selective. Students sometimes paint backgrounds with the same imagination and enthusiasm they might have when painting a wall in their house. Choose the components of your background carefully. The background should reflect the character of the subject. Then paint the background with the same zest you used on the rest of the picture.

If you find it difficult to select a background color, enlist the aid of color chips. Found in most hardware and paint stores, color chips are a great way to test a color without committing paint. Just hold different chips against your painting to help you make your color decisions.

Mary Whyte
COOL
SUMMER
DAY
Watercolor on
paper, 11 × 14"
(28 × 36 cm),
1995. Private
collection.

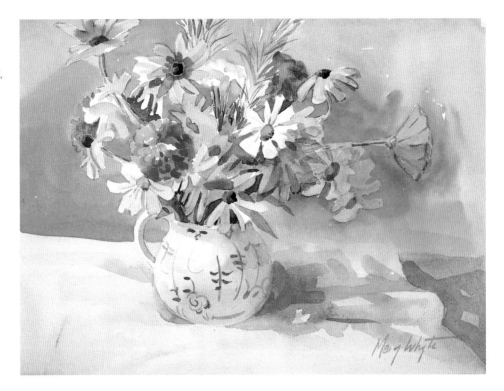

Mary Whyte
HOT
SUMMER
DAY
Watercolor on
paper, 11 × 14"
(28 × 36 cm),
1995.
Collection of
Neil Bjornstad.

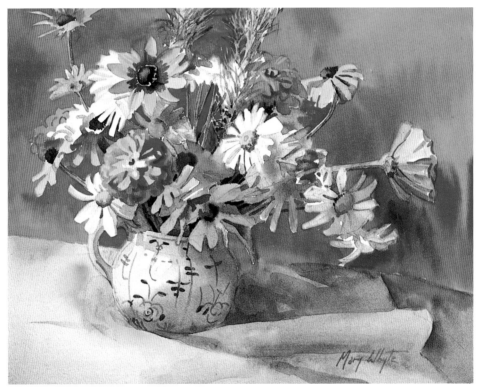

Not surprisingly, background color can affect the feeling as well as the focal point of a painting. Look at the difference between the two paintings above. In *Cool Summer Day*, set against a pale-blue background the red zinnias "pop," making them the center of interest. But in *Hot Summer Day*, another version of the same still life, the zinnias are almost overpowered by a red background.

SELECTING A PALETTE OF COLORS

The colors you choose for your palette and subsequent paintings will largely depend on your own preferences as an artist. Some favor hot, vibrant colors, others like softer, muted hues. Make sure that your palette colors allow you to do both by having a complete selection. For instance, you would find it impossible to mix the cool yellow of a lemon if the only yellow you have on your palette is a cadmium yellow or gamboge. Having a warm and cool version of each of the primary and secondary colors is most important.

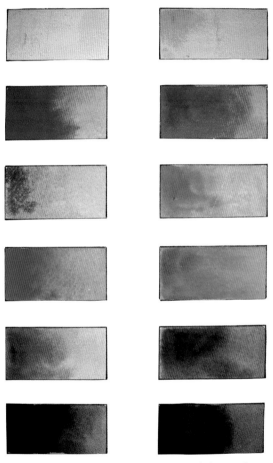

This palette of twelve colors represents a balance of warm, cool, transparent, opaque, and staining colors. I have included Payne's gray, which is a cool color and can be warmed with the addition of brown. *Left column, top to bottom:* cadmium lemon, cadmium red, phthalo green, French ultramarine blue, raw sienna, sepia. *Right column, top to bottom:* cadmium yellow, permanent rose, cerulean, phthalo blue, burnt sienna, Payne's gray.

Suggested Exercises

1. Make your own color wheel incorporating primary, secondary, and tertiary hues. Label each segment with the color or colors used.

2. Make a color wheel as suggested above, but this time, give all the hues the same light value. Then carefully glaze over each hue with its complement. You should end up with a circle of grays all of the same value.

3. On an 8¹/₂-x-11" piece of watercolor paper, paint a 1-x-9" band of black, using acrylic paint or India ink. Then, using each of the colors on your palette, paint even ¹/₂" perpendicular bands over the black. This exercise illustrates to you which colors are transparent and which are opaque. By taking a small, damp brush and gently scrubbing an area of each band after it has dried, you will also see which colors lift easily and which ones are staining colors. (See also "Paint Characteristics," discussed earlier in "Materials.") In watercolor, not all painting effects are created by an additive process. Areas can be lightened or softened by actually lifting out colors that are dry or damp with a sponge or brush. However, some colors actually stain the paper, and no amount of scrubbing will lift them out of the paper's fibers completely.

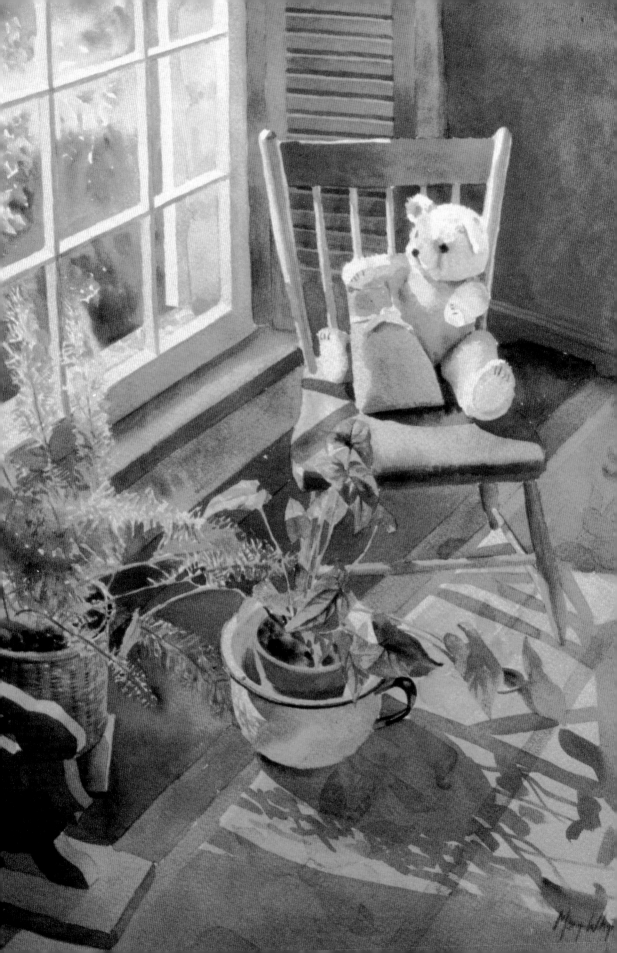

Getting Started

It would be expecting too much to sit a child at a piano and ask him to play music, without his first learning basic scales. The same holds true for expressing oneself in watercolor. Basics must be learned and practiced first. I'm sure that no artist ever picked up a brush and made a masterful watercolor painting on the first try. I'm equally convinced that for beginners, each attempt will bring you that much closer to an understanding of the medium. Like learning to make a perfect omelette, learning effective watercolor technique depends a lot on timing and practice.

As tricky as watercolor may seem to the beginner, there are really only three basic methods of application that you need to know. Numerous special textural effects can be employed, but the entire basis of watercolor boils down to washes, glazes, and wet-into-wet techniques. That's it. These three methods of application make up the foundation of watercolor painting.

Mary Whyte
GUEST ROOM
Watercolor on paper, 27 × 19"
(69 × 48 cm), 1985. Private collection.

As a serious beginning watercolorist, you don't have to look far for lots of paintable subject matter. Familiar, meaningful objects in your own home offer a good place to start. I discovered this still life one morning when I walked by our guest room. I set up my easel and immediately went to work, completing the painting over the next three mornings.

Basic Wash Methods

The first component to all pure watercolor painting is the wash. A wash is a color laid into an area too big to be accomplished by a single brushstroke. A wash can be done on either wet paper or dry paper, but wet paper is generally easier, since the pigment will flow faster and more smoothly, without the look of overworked brushstrokes. A wash can go from light to dark or dark to light, or made to appear to float behind something in the foreground. A wash can also change color, meaning it can graduate from blue to yellow, for example. The type and surface of the paper you use will greatly affect the outcome of the wash. Hot-pressed, cold-pressed, or rough paper will each create a different look.

LAYING A FLAT WASH ON WET PAPER

A flat wash is a painted area with no visible brushstrokes. If the paper is wet, the flat wash will have an airiness to it, making it a particularly useful technique for painting skies. If the paper is barely damp, the wash will have more density and be darker in value. Too much water sitting on top of the paper will cause the wash to wander unevenly.

In order to avoid brushstrokes in a flat wash, it's helpful to wet your painting surface first. Start with a stretched and dried sheet of paper. Using a sponge or a large brush, cover the paper with clean water. Tilt the board so gravity will pull the wash downward evenly.

Mix a large puddle of color on your palette. Always mix more color than you think you'll need, since stopping halfway through the procedure to remix more paint will make the wash look patchy or create backwashes. Starting at the top, use an oval or mop brush to apply your wash with even, consistent strokes.

Be careful not to change the tilt of the paper before the wash has dried. Continue moving your brush evenly across the paper, reloading the brush after each pass. Be consistent with the load and speed of the brush.

LAYING A FLAT WASH ON DRY PAPER

A wash that is laid on dry paper will have controlled edges. If you want a wash to maintain a specific shape, apply it on dry paper, for example, when painting a rooftop or door.

Mix a large puddle of the wash color on your palette. With the board on a tilt, use an oval brush and stroke the paint on, starting at the top. Put enough paint on the brush so that it leaves a slight bead on the bottom edge of your brushstroke. Before the first brushstroke has time to dry, reload the brush and paint the next stroke, touching the bead edge of the previous stroke. It's important to work quickly and with the same speed, always reloading the brush with the same amount of paint.

Without stopping, continue all the way to the bottom. When painting a wash on dry paper, individual brushstrokes may remain visible, particularly if the wash wasn't applied quickly enough. If this happens, don't worry. It's all part of the nature of watercolor and can add to its spirited effect.

PAINTING A GRADUATED WASH

A graduated wash can be painted on wet or dry paper. But I think you will find that you will have considerably more control over this type of wash if it's applied to dry paper.

Begin with your board on a tilt. The more the board is tilted, the more the paint will flow downward evenly. Mix a puddle of wash color on your palette and load your brush. Beginning at the top, stroke your paint on evenly. Reload your brush and paint the next stroke, touching the bead edge of the first stroke before it dries.

With every other brushstroke, add more water to the wash on your palette so that each pass becomes progressively lighter.

Your bottom strokes of paint should be mostly clear water, since the pigment from the upper area will continue to flow downward.

PAINTING A VARIEGATED WASH

A variegated wash combines two washes of different colors on the same paper. The angle and duration of the board's tilt will affect the character of the end result. Touching or trying to manipulate the wash will only muddy it. If you want the two washes to bleed together more, increase the tilt of your board. If you want to slow the blending, lay your board flat.

PAINTING A BACKGROUND WASH

Sometimes you'll want to paint an even-looking wash behind an uneven shape in the foreground. Here, you'll almost always need to wet the area first, particularly if the object in the foreground will be too time-consuming to paint around in one even pass. If you don't want the background to bleed at all in foreground objects, make sure the foreground area is dry first.

Wet a sheet of stretched and dried paper with clean water, using a sponge or large brush. Tilt your board at an angle and apply a color wash to the top half of your sheet, allowing the paint to flow downward. While your paper is still very wet, turn your board upside down and apply the second wash to what is now the upper half of the paper.

Carefully apply water only where you will want the color to flow. Reload your brush with the same amount of color each time, and paint from the top downward. Be sure to paint down both sides at the same time, without finishing one side before the other.

Let the two washes mingle. At this point, it's critical to leave the washes alone.

Continue painting all the way down.

Glazes

A glaze is the application of one color layered over another to give the optical sensation of a third color. Glazing is a way to give luminosity and depth to a watercolor painting. It's also a way to alter or correct colors. For instance, if you're depicting an orange and it's too yellow, by glazing over the yellow with a transparent red, you'll end up with an orange color. Or, say that you're painting a red barn on a distant hill, but the barn doesn't appear to stay in the background. The solution is to use a light, transparent glaze of red's complement, green, painted over the barn to help it recede.

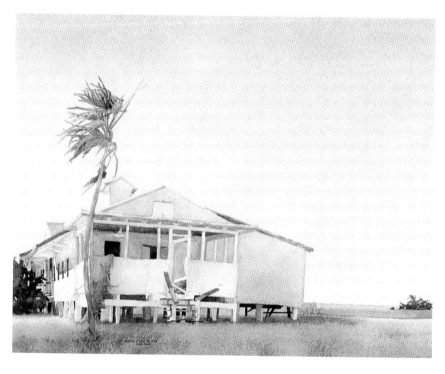

Jeanne Dobie
COLORS OF AN ISLAND EVENING
Watercolor on paper, 16 × 20" (41 × 51 cm), 1995. Courtesy of the artist.

The luminous effect of dusk in this painting is achieved by the artist's use of pristine, transparent washes and glazes, especially on the wall under the porch roof and in cast shadows. The expanse of glowing, early-evening sky is accomplished with one simple wash.

With a glaze, paint the first wash color, starting at the top. Be sure your glaze is bone dry before attempting to go over it with a second wash color.

When glazing over the first wash, be sure to *float* the second wash on it. Try not to disturb what is under the glaze. Once the wash is laid, do not attempt to go back into it, or you may muddy it.

Wet-into-Wet

Painting wet-into-wet is the most exciting and challenging of the three basic techniques, and the results often appear the most lively. With this method, the paint sometimes seems to be more in control of your work than you are—however, the results will be unlike any you could possible contrive yourself. With experience, you'll be able to anticipate pretty much how your wet-into-wet painting will look when it's completed, yet there will always be surprises along the way. That is the unique and true nature of the watercolor medium.

Anytime you paint colors into wet paper or into a wash that is still wet, it is considered a wet-into-wet technique. The edges will always be soft, so it's a technique often employed for backgrounds or shadow areas. The amount of color blending needed depends on the degree of wetness and tilt of your paper.

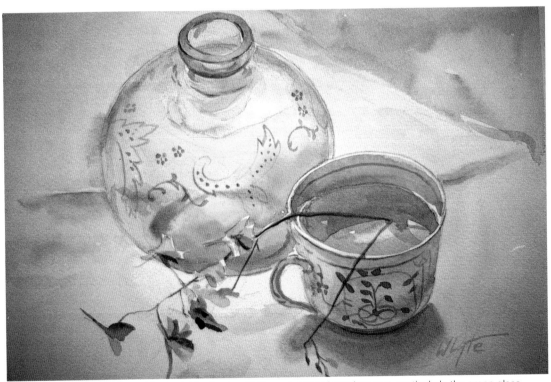

Mary Whyte
SPRING'S GIFT
Watercolor on paper, 9 × 12"
(23 × 31 cm), 1996. Collection
of Mr. and Mrs. Blake Henry.

Much of this simple still life was painted wet-into-wet, particularly the green glass bottle. There I used a combination of cadmium yellow and Winsor green while being careful to paint around the highlight. The design on the glass was added after the initial washes had dried. To paint the design on the glass bottle in raw sienna, I used a #5 round sable brush.

Brushstrokes

The brushstroke is the artist's signature. Each mark should have the integrity of the artist behind it, and the soul of the painting in it.

Let your brushstrokes vary and have life. An angry painting should have fierce, jagged strokes, while a serene painting should have soft, rounded strokes. Learn to make dozens of different types of brushstrokes. The more you increase your painting vocabulary, the more able you'll be to say just what you want to at will.

AVOIDING BACKWASHES

Backwashes, also known as blooms or blossoms, happen when the bottom edge of a brushstroke or wash has too much water in it. Even with the paper on a strong tilt, if the wash has too much water, it will creep back up into the drier area, creating a ringed edge. Be on the lookout for watery edges as you work. Always keep paper towels at hand so you can blot your brush quickly, then use the brush to soak up excess water.

When there is too much water on the bottom edge of a brushstroke or wash, it's called a *backwash*. The same "blossom" effect can occur when water is dropped on a wash that is still damp.

To avoid backwashes, watch for watery bead edges. To pick up the bead, blot your brush on a paper towel and then touch your brush point to the bead of paint. The thirsty brush will absorb the excess paint.

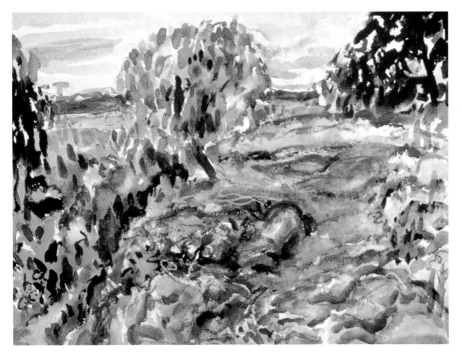

Nell Blaine
ROCKS, SUNSET AND BIRD CHERRY
Watercolor and pastel on paper, 18 × 24" (46 × 61 cm), 1994. Courtesy of Fischbach Gallery, New York.

The lovely lyrical brushstrokes of this painting by Nell Blaine (1922–1996) create rhythm and a colorful energy. Notice how each brushstroke is uniquely interesting yet remains part of the whole image.

Edges

Being able to recognize and treat hard, soft, lost, and found edges is a fundamental part of developing sound painting skills. Many beginners in the watercolor medium initially treat all edges in the same way, perhaps because their conception of shape is defined by outline, rather than volume. Working strictly from photographs can perpetuate this shortsightedness, since photography tends to flatten an object visually by limiting the nuances of color and value. If you are going to work from photos, you'll need to compensate for the two-dimensionality of the image. Drawing and painting from life is the best teacher I know of for learning how to handle edges and portray volume.

The character of an edge tells us a great deal about what we are looking at. For one thing, the edge tells us what kind of texture the object has. A hard edge indicates a stiff, solid surface or a quick-turning edge. A soft edge indicates a yielding, fluffy, or supple surface or a rounded edge. The type of edge also tells us where something sits in space. An object that is close will have a more distinct edge than an object that is farther away.

The manner in which you treat an edge can also direct the viewer. A hard edge will invite attention and project interest, while a soft edge will play a more neutral role in the composition.

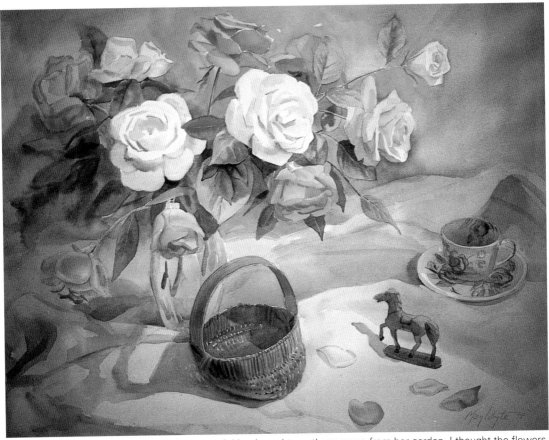

Mary Whyte
THE END OF SUMMER
Watercolor on paper,
20 × 27" (51 × 69 cm),
1995. Collection of Mr.
and Mrs. Herb Moore.

One morning, my neighbor brought me these roses from her garden. I thought the flowers were so beautiful that they warranted a painting, so I created this still life, using what I felt was an interesting combination of contrasting textures. Painted on 140-lb. Arches cold-pressed paper, much of the painting was worked wet-into-wet to portray the soft edges of the background, shadows, and receding roses.

You can soften an edge in two different ways; the first, while the wash is still wet. After you've applied a wash shape or brushstroke, immediately rinse your brush and blot it once on a paper towel. Then quickly trace around the outside edge of the area, just touching the wash with your damp brush. This "halo" of dampness will soften and slightly extend the first shape.

If an edge that needs to be softened has already dried, use a damp, round brush and lightly scrub the edge. If the color is a staining color or just plain stubborn, then work on it with a small, damp bristle brush—the kind generally used for oil painting.

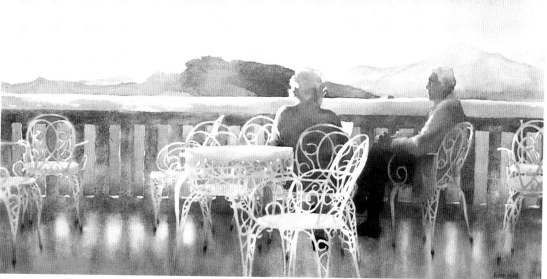

Jeanne Dobie
TWILIGHT ZONE
Watercolor on paper,
20 × 30" (51 × 76 cm),
1993. Courtesy of the artist.

The sensitive treatment of edges contributes to the overall success of this beautiful painting. Look at how effectively the hard edges of the chairs contrast with the composition's softer edges, such as the reflections on the floor. Also notice how the crisp edges of the figures' heads projects them as the main area of interest.

Textures

Every object has some sort of texture: smooth, soft, rough, grainy, wet, slippery, and so forth. Visual characteristics might include reflective, dull, transparent, translucent, opaque, or misty. Knowing how to paint different textural characteristics is a necessary skill for any artist. Ultimately, knowing how to paint a wide variety of textures will increase your artistic vocabulary and enable you to express almost any subject on paper.

Be careful not to rely on recipes. Although it's fun to create textural effects, they can end up being the downfall of a painting. The viewer should not look at a picture and be overly aware of the technical processes used to construct its image.

If you keep your work earnest, using special effects with judicious care, they can add richness and depth to your compositions. There are dozens of ways to create such effects, but the four most basic techniques that you should know are lifting, spattering, dry brush, and resists.

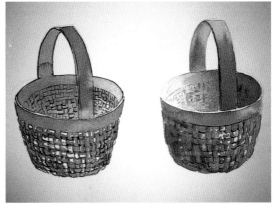

So often what attracts us to an object is its texture: the rough bark of a tree, the shiny surface of a copper pot, the soft fur of an animal. However, no amount of labored textural detail will make an object look three dimensional if you haven't painted the mass first, as seen in this illustration of two baskets. The basket on the left is painted with texture; the basket on the right has less texture and detail, but it looks rounder because I painted the volume first.

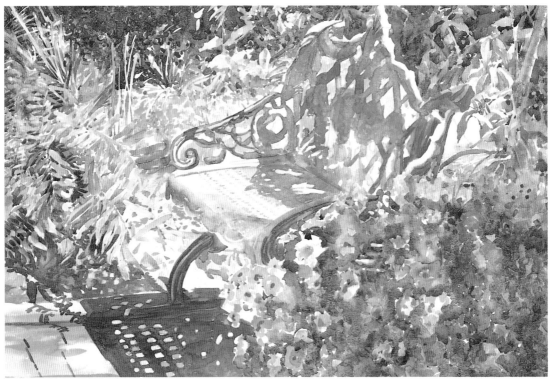

Margaret Petterson
GARDEN BENCH
Watercolor on paper,
24 × 36" (61 × 91 cm),
1996. Courtesy of the artist.

A variety of textures and edges will always help to give a painting interest. In this image, the artist has successfully employed the three different ways of applying watercolor: washes, glazes, and wet-into-wet techniques. Washes were applied in areas such as the pinkish color seen in the negative shapes behind the chair; glazes were used in many of the cast shadows; wet-into-wet technique was employed in the green foliage in the right foreground.

LIFTING

This is the process by which you remove color from the surface of your watercolor paper. You can use a sponge, paper towel, brush, sandpaper, or a sharp instrument like a razor blade or knife. Sometimes the lifting technique is successfully employed for making a correction; at other times, it's used to create a lightened area or to place a highlight.

When using sandpaper or a razor blade, you will actually be removing the top layer of paper, so a light touch is needed. Be careful not to sand or scrape too deeply or you'll leave a noticeable scar on the paper. After you have sanded or scraped the area, rub it lightly with the smooth, flat edge of your fingernail.

Color is also lifted by rubbing it with a damp brush or sponge. If the area is still wet, you can blot it with a paper towel to create soft, round, light areas. This technique works well for depicting puffy white clouds or for lifting out the soft highlights in hair.

SPATTERING

Spattering is produced when paint is flicked from a brush onto paper. The smaller and stiffer the brush, the smaller the dots of spatter. An old toothbrush gives an especially fine spatter when you stroke your thumbnail against its bristles. A large, round sable brush gives a larger, less controlled spatter. Another method of spattering is to use liquid frisket, or masking liquid, for spattering lights into darker washes. This can be an effective way to paint a starry night or baby's breath in a floral arrangement. Be sure to place a paper towel or piece of paper over areas that you do not want spattered.

DRYBRUSH

Despite the word *dry,* when you use this technique, you dip a damp brush into a minimal amount of paint and then drag the hairs across your paper surface. Splitting the brush hairs apart as well as holding the brush handle low to the paper will enhance the rough effect. This texture is often used by watercolorists to simulate the look of wood grain.

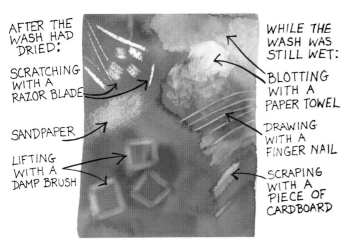

Lifting techniques are used to lighten an area. Most lifting techniques such as blotting, rubbing, or sanding will leave a lighter value with a soft edge. Scraping with a knife or razor blade will leave a whiter white and a sharper edge.

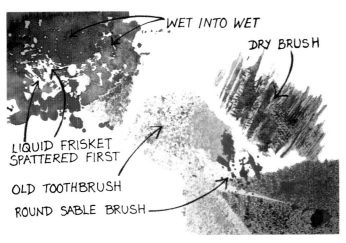

Spattering and drybrush techniques give a more granular and broken appearance. The size and type of your brush hair as well as your paper surface will greatly affect the outcome of these two methods. Cold-pressed and rough papers generally work best.

RESISTS

When you want to preserve the white of your paper in certain areas of a composition, one way is by using masking fluid, or liquid frisket over those parts. Available through most art supply catalogues, it usually comes in a two- or three-ounce bottle. Apply liquid frisket with an old brush, as it can be difficult to remove the dried frisket from it. To protect the brush hairs, I find it helpful to wet my brush and rub it against a bar of soap before dipping it in the frisket. After you've finished your painting, you remove the frisket from your paper by rubbing it with your fingers or with a piece of crepe rubber.

Avoid leaving frisket in place for any length of time, as it will yellow your paper. Pieces of ordinary masking tape, stocked by hardware stores in many widths, will also act as a resist. Again, avoid leaving masking tape on a painting for too long, as it, too, will yellow the paper. Other resists that give attractive results are crayons and wax candles. They will repel any washes and create a calligraphic look.

OTHER TEXTURAL EFFECTS

Try some or all of the following techniques. Each one produces its own distinctive look.
- Sprinkling salt into wet washes produces tiny snowflake-shaped spots, an effect that's useful for flurries or the spray of a breaking wave.
- Stamping with a sponge will give rough, granular shapes similar to the look of foliage.
- Crinkling plastic wrap into a wet wash produces angular lines and broken shapes ideal for simulating the texture of rocks.
- Adding ox gall, a drying retardant and paint extender, or gum arabic, watercolor's natural binding ingredient, to your paint will add a greater degree of flow, transparency, and luster to your washes.

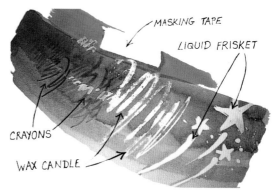

Resists are a way to preserve the white of your paper. Liquid frisket will leave a stark-white shape with a hard edge. Some watercolorists feel that liquid frisket leaves an "unnatural" edge, so they go back later and soften the shape's contours with a stiff, damp brush. Crayon and wax will repel subsequent washes, leaving behind interesting, energetic lines. Masking tape will leave a combination of crisp-looking straight and ragged edges.

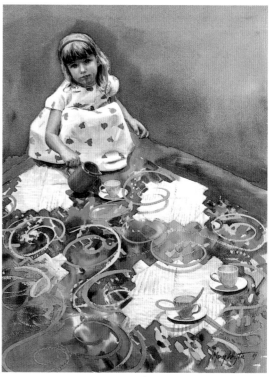

Mary Whyte
ALICE
Watercolor on paper,
24 × 19" (61 × 48 cm), 1990.
Private collection.

Sometimes a face will prompt an idea for a painting. This little girl had a classic storybook face that reminded me of *Alice in Wonderland*. I imagined her at the Mad Hatter's tea party with cups and saucers swirling, and achieved the effect of motion with the aid of liquid frisket to mask out the circular strips. Later, after I had removed the frisket, I painted the swirls in color.

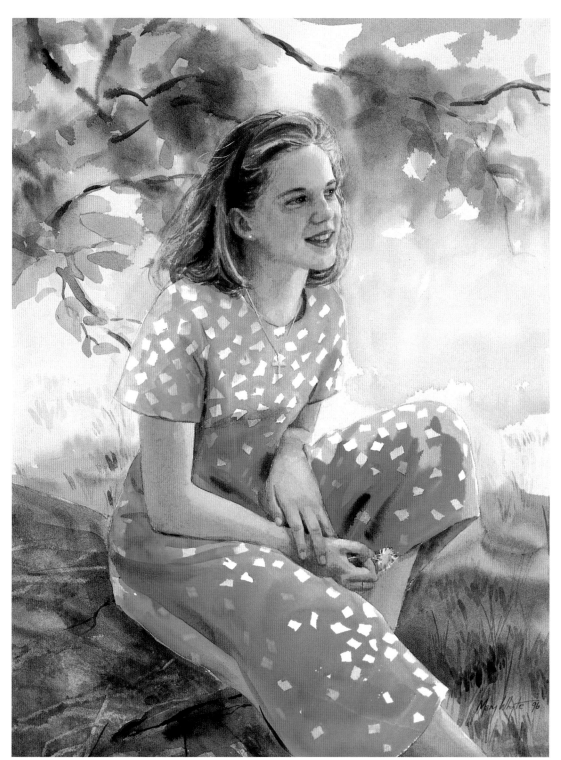

Mary Whyte
PORTRAIT OF
ELISABETH
Watercolor on paper,
25 × 20" (64 × 51 cm),
1996. Collection of
Elisabeth Bux.

I have known this young girl all of her life. She posed in a blue dress that had a more intricate pattern than you see here. I simplified it by masking out its white shapes, using little pieces of torn tape, which I applied before I painted the blue washes of the dress. After the washes had dried, I peeled off the masking tape. The painting was done on Arches 140-lb. cold-pressed paper.

Combining Mediums

Working with different mediums can open the door to invention and lend a variety of intriguing effects to watercolor painting. For years, artists have experimented by combining watercolor with pastels, pen and ink, and more opaque mediums such as gouache or acrylic. Joseph Mallord William Turner (1775–1851) experimented with the different effects of translucent washes on white paper to achieve his images of "tinted steam." Turner even went so far as to paint a red sun on the back of his watercolor paper, then lightly scraped away the surface on the front, giving the illusion of sun shimmering through fog. I often wonder how many innovative discoveries like this might never have been found if the artist had been bound by convention or stopped short, thinking he had made a mistake.

Water-soluble pastels blend beautifully with watercolor washes and make for lively underpainting. By vigorously drawing with the pastels and then blending with clean water or colored washes, the resulting soft lines and mingled colors can set the groundwork for further painting.

Ink lines can be applied before or after watercolor washes. If the paper is still wet when the ink is applied, the lines will widen or run. Personally, I like to apply ink lines after my watercolor has been applied and is dry, since sometimes the washes will give me added ideas of what to add to the drawing.

Mary Whyte
SUNFLOWERS
Watercolor, pastel, and Aquacryl,
29 × 21" (74 × 53 cm), 1996.
Private collection.

Watercolor works well in combination with several other mediums. In this case, I combined both pastel and a product with a water-soluble acrylic base, Aquacryl, which acts much like watercolor in that it is transparent, but feels more like acrylic in its thick texture and the way it dries. Aquacryl will allow you to paint light passages over dark passages much the same as acrylic will, but unlike acrylic, which is permanent when dry, Aquacryl will lift or soften with a damp brush. In this painting, the background was laid in with blue washes. After the washes were dry, I added yellow pastel on top and then glazed over that with white washes. This type of layering with the two mediums gives an added illusion of light and depth. Pastel lines that have been glazed over with washes of Aquacryl will soften and blend with the paint.

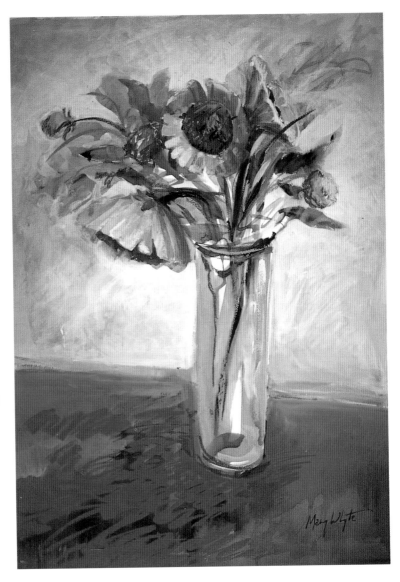

Correcting Mistakes

Watercolor is more forgiving than you may think. Of course, it is nothing like oil or acrylic, where a mistake can be completely painted over, but even oil and acrylic can look overworked from too many corrections.

The safest way to proceed with watercolor is to paint very lightly at first, and then gradually darken the values. If overall the painting is still light in value, corrections can be made easily. Pencil lines can be erased through light, dry washes and then be redrawn. When colors are very pale, almost anything can be painted over them, and changes can hardly be detected in the finished painting. Be careful, though, if you decide to erase your pencil lines and redraw. Be sure your paper is completely dry. Erasing on damp paper scuffs the surface. Drawing into wet paper creates grooves that will later collect dark pigment from subsequent washes.

Some of your greatest discoveries about the watercolor medium will be the result of what you may initially think is a mistake. I once was trying to paint a sandy beach and wasn't happy with what I was getting. I took the painting into the bathroom and attempted to scrub it under an open faucet. The colors mingled and softened, creating the perfect texture for depicting sand. Since then, painting an area and then softening it under running water is a technique I sometimes use on purpose.

Not every color is responsive to scrubbing and lifting. (Refer to the color chart and information on paint characteristics in "Materials.") Many nonstaining colors will wash off to a certain degree. Other colors are stubborn. If using a sponge or brush proves unsuccessful for lifting an area, the next option is to overpaint that section with gouache or acrylic. But a word of caution here: Completely opaquing an area with white paint is generally not the best solution; it often reads as a mistake you're trying to hide. If you incorporate acrylic or gouache to make an adjustment, weave it into your composition subtly so that it appears to be an integral part of the painting.

The last resort, and frequently the best solution to correcting a painting with too many mistakes, is simply to start over. No matter how much time you've put into a painting, nothing can save a watercolor that is muddy or overworked. Look at your first attempt as a useful step in getting the bugs worked out. Then take another sheet of paper and give it a fresh start.

Suggested Exercises

1. Take six 8 × 10" sheets of watercolor paper and draw the outline of a 5" star in the middle of each sheet. Then keeping the star the white of the paper, paint six different backgrounds, using: (a) flat wash on wet paper; (b) flat wash on dry paper; (c) graduated wash; (d) variegated wash; (e) glaze; and (f) wet-into-wet technique.
2. Using a variety of brushes, see how many different brushstrokes you can make on one sheet of paper. Push, pull, drag, and twist your brushes. Make some marks with hard edges and some with soft edges.
3. Try each of the special effects listed in this chapter. Invent three more of your own.

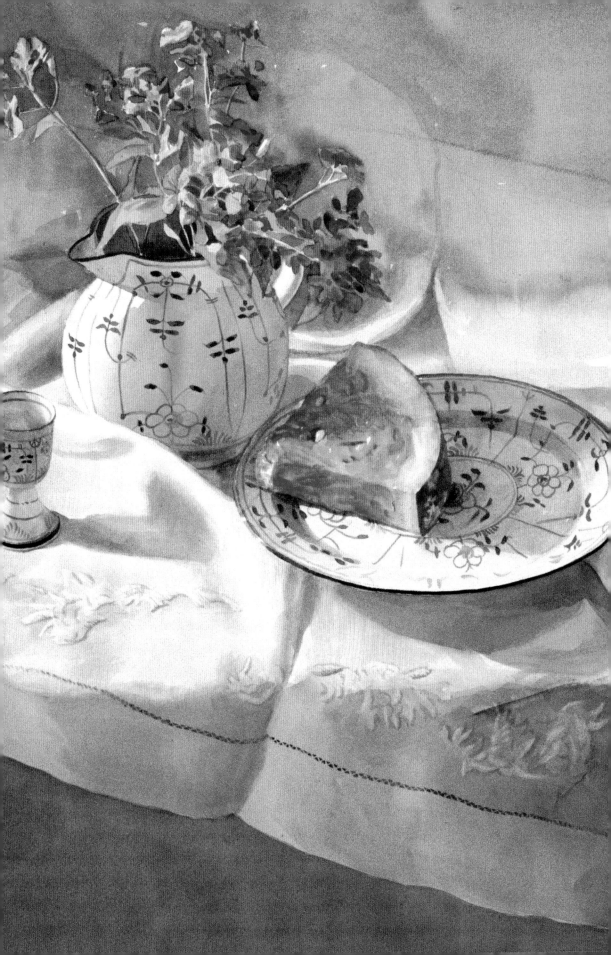

Still Life

For many reasons, still life easily lends itself to the agenda of beginning artists. Objects can be studied closely and rearranged without difficulty. Illumination and backgrounds can be manipulated at will, and there is never a shortage of subject matter. Unlike landscape painting, still life frees the artist from the inconsistencies of weather. And unlike figure painting, you will never have to worry about the model changing position or quitting.

There is also an inherent intimacy about still life that makes it all the more engaging. As each piece for the still life is selected and placed in position, tactile sensibilities come into play. Choosing subject matter from your own personal collection of favorite dishes, antiques, plants, shells, and textiles can be enormously satisfying.

The act of painting the still life is conducive to most situations. Since the artist generally sits or stands a short distance away from the still life, even the smallest of workspaces will suffice.

Mary Whyte
A SLICE OF WATERMELON
(DETAIL)
Watercolor on paper,
19 × 27" (48 × 69 cm), 1991.
Courtesy of the New York
Graphic Society.

This painting was initiated as a class demonstration to illustrate the value range of white objects. Unity is created in the painting by the repetition of round shapes. The pinkish red of the watermelon activates the surrounding neutral colors and becomes the picture's focal point.

Setting Up a Still Life

The key to selecting elements for a still life is unity and variety. Objects must have something in common; for instance, they might be round. But they must also have variety so they don't become boring. Too much of the same motif will look like wallpaper. Too many different, unrelated objects will look chaotic.

Instead, choose objects that have a range of forms and interesting textures for variety. Remember, the number-one job of a painting is to appeal to the senses. For unity, study how your still-life items relate to one another. Then study how light affects each object; how light passes through glass, reflects off shiny objects, or bounces color into shadows.

Don't underestimate the importance of shadow shapes and their role in tying together the entire composition.

And of course, don't overlook the background and the great impact it can have on everything in the foreground.

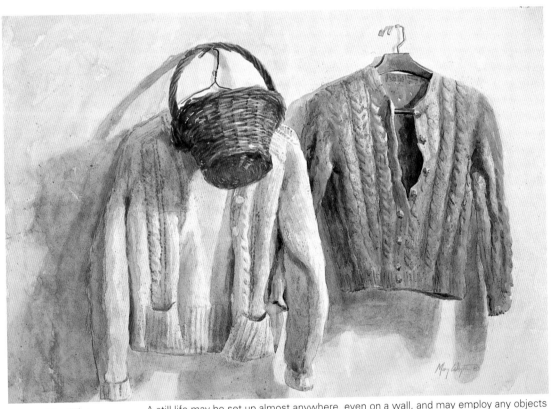

Mary Whyte
FAREWELL
Watercolor on paper,
29 × 34" (74 × 87 cm), 1983.
Collection of the artist.

A still life may be set up almost anywhere, even on a wall, and may employ any objects you find interesting or compelling. I painted this a few weeks after my mother passed away, using our two sweaters and a basket that previously had been filled with flowers from the memorial service.

Wherever a still life is created, the setting becomes a stage. A windowsill, table, chair, or floor can serve as a suitable arena for your arrangement. The setup can be at eye level, above or below it, but should always be positioned in a way that is near enough for you to see everything clearly.

FIVE TIPS FOR SETTING UP A STILL LIFE

- Start with a few simple objects that vary in size, shape, color, and texture. These will provide the most interesting possibilities for your arrangement.
- Don't scatter elements of your composition; create depth and unity by overlapping some of the objects. Use cast shadows to connect objects visually.
- Create interest and vitality by using contrasts: light against dark or rough objects against smooth ones.
- Use a dominant light source to help describe shapes and to create stronger shadows and highlights.
- Look for unexpected possibilities. Forget about using clichéd, meaningless objects like a wine bottle with a candle in it. Select objects you find exciting, and your enthusiasm will be passed on to the viewer.

Kass Morin Freeman
GEARING DOWN
Watercolor on paper,
21 × 32" (53 × 81 cm), 1992.
Courtesy of the artist.

Is this a still life? If a still life is a pleasing arrangement of shapes, then it is. The bold shapes, interesting shadows, and variety of textures combine successfully for a dynamic painting. Note, too, how the touch of warm red gives relief to the overall green color.

Lighting

Working from either direct sunlight, diffused light, or artificial light will produce very different results in your still life. Direct sunlight will provide the greatest contrasts and brightest highlights. Diffused light, such as a north light, will create truer colors and softer shadows. Artificial light is advantageous because of its consistency over long periods of time. Remember, though, it's not the type or source of light that's important, but how you incorporate light into your composition. The shapes of light and shadows and their placement within your picture plane have everything to do with how successful your end product will be. In other words, the distribution of lights and darks is a fundamental component of a painting.

Mary Whyte
SHORE STILL LIFE
Watercolor on paper,
19 × 24" (48 × 61 cm), 1990.
Collection of Mr. and
Mrs. Tom Williams.

I arranged this still life outside in a sunny location and painted it over the course of two mornings. I have painted these dishes many times—partly because of their sentimental value, but also because I enjoy their whiteness and hand-painted designs. The shells and napkin add variety of shapes and textures. As I recall, the sky both mornings was slightly overcast, which created clean colors and soft shadows in the still-life arrangement. If you are going to break up your painting time into two or more sessions, be sure to wait for the lighting to be the same on subsequent days.

Shadow Box

If still-life objects are to be seen to best advantage, a suitable background or setting is a must. For centuries, still-life painters have used the shadow box for this purpose. It isolates a still-life arrangement from the rest of the room, and allows you to set up interesting shadow effects. Many forms of boxes are used, designed with either three, four, or five sides.

The most basic and least expensive version is simply a cardboard box, cut in a way so that the wings can be swung open or closed. Cloth or colored paper is draped in or across the box to provide background color.

Artists relegated to sporadic working sessions on the dining room table will find the shadow box to be a most helpful tool. While visually isolating your still life from the rest of the room, at the same time, the box allows you to easily pick up and transport the entire arrangement to another location when necessary.

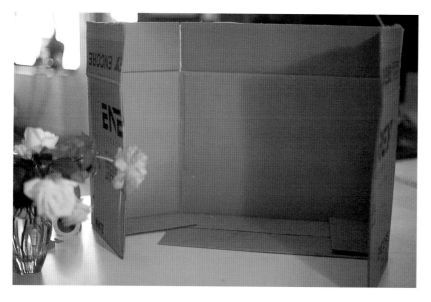

A cardboard shadow box is quite versatile. Wings can be cut so that the sides of the box may be opened or closed. Notice how the wing on the right casts a diagonal shadow over the central area.

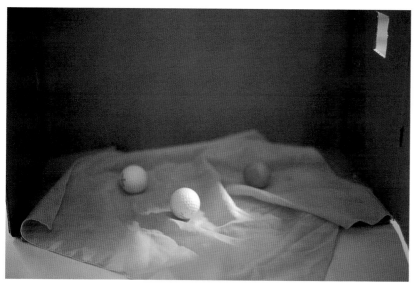

If you cut a window into the side of your shadow box, it will admit a narrow band of light that can be aimed at specific objects.

Demonstration: Simple Still Life

Keep your first attempts at still life limited to just a few different objects—three or four at the most. Don't worry excessively about getting your painting to look just like the actual objects. Too much emphasis on portraying exactly what is there can result in stiff, overworked painting. Instead, concentrate on the biggest shapes you see and the magic of the medium. Being able to paint basic geometric shapes is the foundation of watercolor. Square and rounded forms are in everyday objects all around us, and are useful for practicing smooth washes.

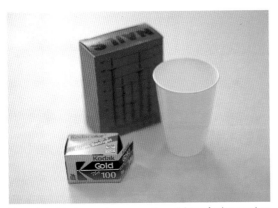

Everyday objects are always good candidates for interesting still-life paintings. Here, a red box of nails, a yellow film box, and a yellow plastic cup serve as models. The rectangular shapes of the boxes are complemented by the cup's cylindrical shape.

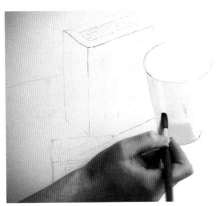

Step 1. My initial drawing is made on a sheet of Arches 140-lb. cold-pressed paper that has been stretched and allowed to dry. I use a #2 pencil to draw the basic shapes, erasing any unnecessary lines with a kneaded eraser. Then I paint the yellow cup with a wash of aureolin. While the wash is wet I add a hint of blue to the right and a little cadmium to the bottom to suggest bounced light. The soft highlight on the cup is lifted out with a damp brush.

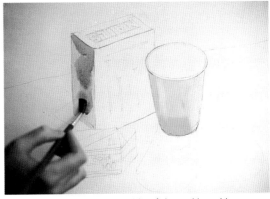

Step 2. To depict the cool side of the red box, I let two colors mix themselves on the paper. First, I paint in a wash of ultramarine blue. While the blue is still wet, I charge in some permanent rose. When letting the two colors mix themselves on the paper like this, it's important to paint the passage quickly and then leave it alone.

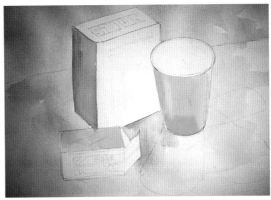

Step 3. Backgrounds should be tackled early. Here, washes of ultramarine blue, cadmium red, and Winsor blue are painted in. Remember always to start with a wash at the top and to let it flow downward. I also establish a cast shadow under the box of nails, and paint the top of the film box.

Step 4. I paint the darker and warmer sides of the nail box, using cadmium red and burnt sienna, leaving a white area on top of the box for a detail to be added later. Notice how I develop the blue shadow at the same time, allowing the colors to swim together in the shadows.

Step 5. The background is reworked, using slightly darker washes. Because there are multiple light sources, the objects cast numerous shadows. Notice how the color of the cup is reflected in its shadow. I also paint the shadow sides of the film box and the inside of the cup.

Step 6. Highlighted areas such as the corner of the box are created by light scrubbing with a damp brush.

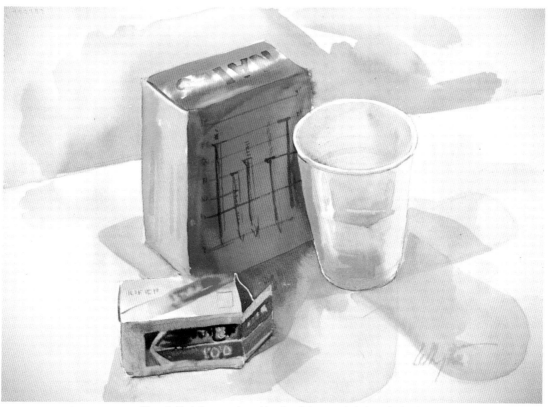

Mary Whyte
STILL LIFE WITH BOXES
Watercolor on paper, 14 × 16"
(36 × 41 cm), 1995. Private
collection.

Step 7. To bring out the white lip of the cup, I darken the background with another wash of ultramarine blue. I also darken the cast shadows from the cup. Light glazes using raw umber add slight indentations to the surface of the plastic cup. When you are painting objects with lettering on them, it's best to suggest the writing only, so as not to distract from the picture's overall image.

Demonstration: Still Life with Coffee Cup

When choosing objects for a still-life painting, look for interesting shapes and a variety of textures. However, the objects should communicate with one another visually or thematically. An object can become even more interesting when placed next to another object that contrasts in shape, color, or texture. Composing a still life so that some edges overlap gives more unity to the picture.

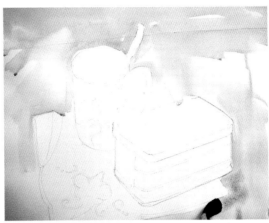

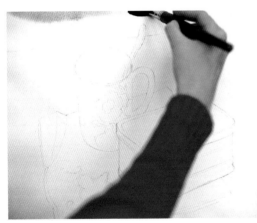

This photograph shows a simple still-life setup comprising four objects. Notice how they are arranged so that each overlaps another, creating a unified composition.

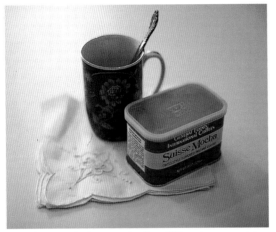

Step 1. After sketching the still life on paper that has been stretched and allowed to dry, to encourage a smooth, fluid wash in the background, I wet that area first with clean water. Before the clear wash has dried, I paint in the background with a large brush. The board is tilted almost upright, allowing gravity to pull the blue wash downward evenly.

Step 2. Farther down the paper, I change the color to Winsor blue with a little Winsor green in it. To suggest a warm shadow in the foreground, I quickly charge in some raw sienna. Notice how little bits of white paper are left untouched where my background wash is applied, which helps to give the painting a more spontaneous look.

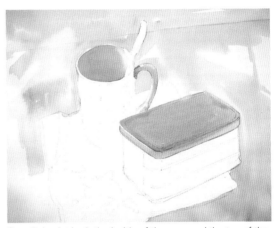

Step 3. I paint both the inside of the mug and the top of the box by letting two colors mix themselves. The interior of the mug is Winsor green and raw sienna painted wet-into-wet; the top of the box, in Winsor green and permanent rose, is painted in the same manner. To give more interest to the background and unify it with the red object in the foreground, I touch in a bit of permanent rose mixed with raw sienna. This was done while the blue wash was still wet so that both colors would blend together softly.

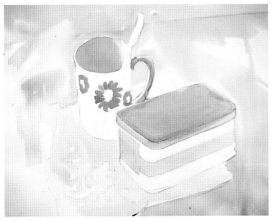

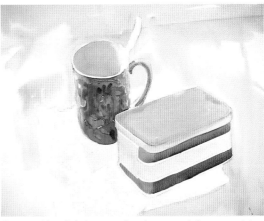

Step 4. The decorative surfaces of the objects are painted in only after the large shapes are established. I use permanent rose and a #10 kolinsky brush to begin the design on the mug. The napkin has been painted wet-into-wet with a warm raw sienna and a cool ultramarine blue. I let the brush skip over the embossed areas of the napkin.

Step 5. After lightly rewetting the area of the mug with clean water, I paint in the flower design. The damp surface will blur the pattern, simulating the look of being in shadow. The flower pattern's soft edges contrast with the crisp edges I used elsewhere, such as the edge of the mug. Here, I was careful to leave the white of the paper showing to give the effect of light hitting the mug rim. The can's red stripes are painted with permanent rose and raw sienna. While the wash is still wet, I add ultramarine blue to the stripe on the shadow side of the can.

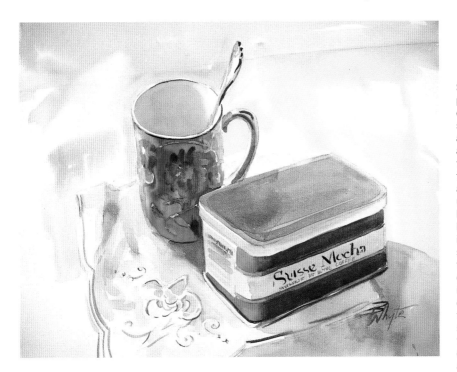

Mary Whyte
A CUP OF MOCHA
Watercolor on paper,
16 × 19" (41 × 48 cm),
1995. Private collection.

Step 6. My finished painting is a combination of contrasts: hard and soft edges, focused and unfocused areas, and different surface textures. The finishing touches on the napkin are made with ultramarine blue and a little raw umber. Always keeping the light source in mind, I paint in the soft shadows of the fabric folds and the cast shadows of the mug and can. A few crisp strokes are made to the mug's rim, the spoon, and lettering on the can. Lettering, as on the can, should always be done with a suggestive, light touch so the viewer is not forced away from the aesthetic aspects of the painting.

Demonstration: A Bunch of Radishes

Kitchens are abundant with wonderful subject matter to paint. We become so accustomed to our everyday objects that we often overlook their unique and interesting qualities. When choosing subject matter, forget about the identity of the object—such as a dish or an apple. Instead, focus on the object's character: its shape, contour, color, texture, light, and shadow.

A simple bunch of radishes presents a variety of interesting shapes that need to be studied closely. See how different the flat, angular shapes of the leaves and tag are from the rounded shapes of the radishes. Noting the intrinsic character of an object is the first step in being able to paint it.

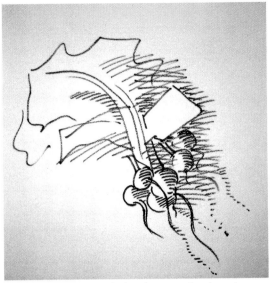

A quick drawing to study the shapes and various degrees of light is time well spent. Always consider shadows as part of your composition.

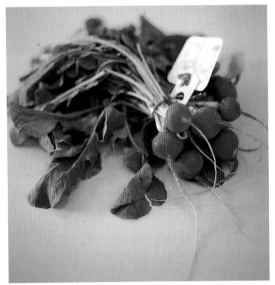

Your painting can never be too simple or too interesting. A single bunch of radishes offers the opportunity to explore numerous organic shapes. The roundness of the radishes contrast nicely with their linear leaves, and their respective red and green colors present good complementaries with which to work, while the white tag adds a bright note and still another shape. Interesting calligraphic shadows can be cast by the vegetables' long, tapering roots.

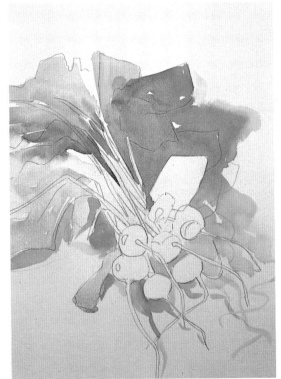

Step 1. First I stretch a small sheet of Arches 140-lb. cold-pressed paper and allow it to dry thoroughly before drawing with a #2 pencil. Then, using Winsor green and new gamboge, I quickly paint in the leaves. While that area is still wet, I brush on ultramarine blue and Winsor violet for the shadows, letting those colors mix with my greens. Painting washes like this is easy. The hard part is to resist going back in and "noodling around."

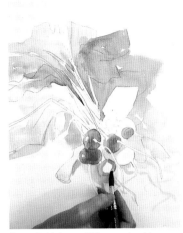

Step 2. Using a #10 round sable brush, I paint each radish in three quick stages. I start with a violet-blue blend of permanent rose and ultramarine blue on the light side, being careful to go around my highlights. Then, after rinsing and lightly blotting the brush, I paint raw sienna on the opposite side of the radish, to suggest a bounced light. The third step is painting a rich, vibrant hue of cadmium red in the middle, lightly touching the other colors so that they all blend together.

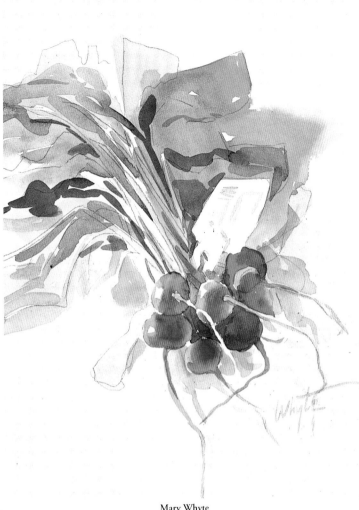

Mary Whyte
A BUNCH OF RADISHES
Watercolor on paper,
15 × 11" (38 × 28 cm), 1995.
Collection of Joan Pine.

Step 4. Notice the variations I employed in painting the leaves and radishes. I used a range of warm and cool colors, hard and soft edges, detailed and suggested areas. In including the grocer's tag for its geometric shape, I was careful to only hint at the writing on it.

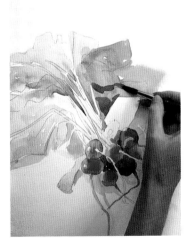

Step 3. After establishing the light and middle values, now it's time to add the darks. I always keep in mind which direction my light is coming from, and let my brushstroke describe the mass of what I am painting. I let the underpainting dry completely to give me control over the placement of my darks, for which I use blends of Winsor green, new gamboge, and ultramarine blue. When placing darks, I'm careful to vary their darkness and color temperature.

Demonstration: Still Life with Potatoes

Transparent objects like glass bowls require careful observation. Note how objects as seen through glass are slightly different in color and have irregular, soft edges. The highlights on glass are much lighter and crisper than those on less reflective surfaces such as potatoes or fabric.

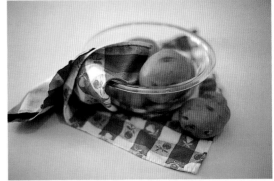

Texture plays a major role in still life. This setup of a transparent bowl, soft napkin, and hard potatoes all gain strength in their identity because of their differences from one another. In choosing these objects for my still life, I establish a palette that will feature the juxtaposition of red with its complement, green.

Step 1. After drawing in the basic shapes with a #2 pencil, I begin laying in the background washes, using ultramarine blue, Winsor green, and a touch of permanent rose. The background is white in reality, but to make the bowl stand out, I need to darken some area around it. I paint the shadow areas in the cloth and the bowl together, using ultramarine blue, permanent rose, and raw umber, then lift out the reflection in the glass, using a barely damp brush. In shadow areas, I generally paint wet-into-wet to allow the edges to soften and the colors to swim together. When I want a crisp edge like the forward rim of the bowl to advance, I make sure the paper is completely dry before touching the area.

Step 2. I begin suggesting the folds of the cloth, using Winsor blue, raw sienna, and permanent rose. Being careful not to lose the white highlights in the glass, I loosely lay in more washes to define the bowl and the fabric a bit more. Notice how at this stage there are no details, only basic shapes, and the potatoes have not been touched yet. Best results are had when the largest shapes are established before a focal point is painted. Painting the focal point first and leaving other areas for last leaves too many painting decisions to chance.

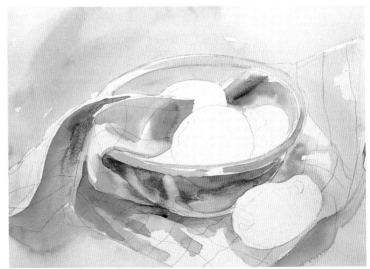

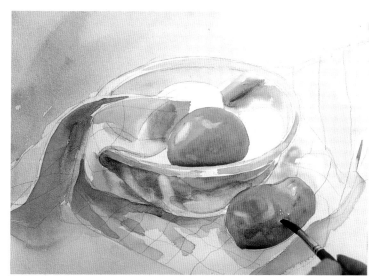

Step 3. The potatoes are painted wet-into-wet with a #10 round brush. I use raw sienna, permanent rose, and Winsor violet, with a little extra ultramarine blue on the shadow side. While the wash is still wet on the potatoes, I lift out some soft highlights, using a "thirsty," damp brush. By rinsing then blotting your brush on a paper towel, it will actually pick up water. Touching the very tip of the brush to a bead of wash will pull the wash back into the brush. Moving the tip or body of a thirsty brush back and forth in a damp area will pull out a light, soft shape.

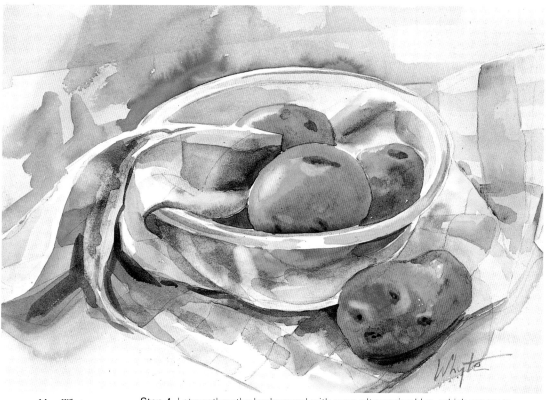

Mary Whyte
ONE POTATO,
TWO POTATO
Watercolor on paper,
10¹/₂ × 14¹/₂" (26 × 36 cm),
1995. Collection of Mary
Schwinn.

Step 4. I strengthen the background with more ultramarine blue, which serves to define the edge of the glass bowl more clearly. For variety, I paint each eye in the potatoes differently. In depicting the napkin, I'm careful to suggest its green-and-white pattern subtly, rather than reproducing every square literally. Remember, when you paint pattern, you must understand and describe the volume beneath the pattern first. You have to bake a cake before you can decorate it.

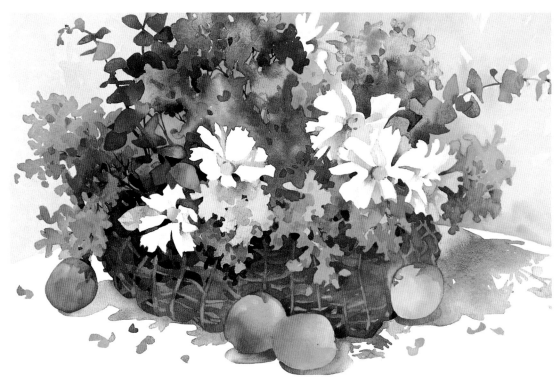

Jean Uhl Spicer
JUST PEACHY
Watercolor on paper,
14 × 21" (36 × 54 cm), 1995.
Courtesy of the artist.

The variety of textures and warm, rich colors help to bring this composition alive. The crisp whites contrast nicely against the darker, puddled areas of foliage. Notice, too, how the daisies and peaches are grouped in an interesting manner. Instead of isolating each daisy and peach, the artist creates pleasing shapes by letting the objects touch or overlap realistically.

Mary Whyte
OPAL
Watercolor on paper,
19 × 14" (49 × 36 cm), 1995.
Collection of the artist.

Because of their colorful geometric patterns, quilts make interesting subject matter. This quilt, from my own collection, contrasts nicely in shape and texture with the pears and cat. The coolness of the blue-green background also contrasts well with the warm foreground colors. Since most of the cat is in shadow, I painted her wet-into-wet, beginning with a wash of Winsor blue and permanent rose. While the wash was still wet, I lifted out small areas of paint to suggest tufts of fur.

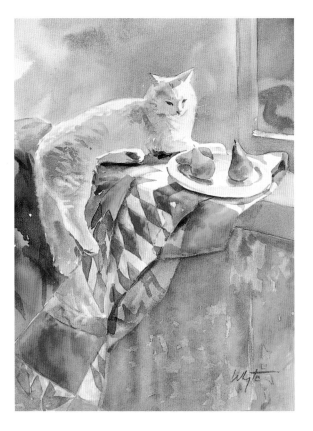

Mary Whyte
LATE FOR TEA
Watercolor on paper, 18¹/₂ × 21"
(46 × 53 cm), 1992. Courtesy of
Salem Graphics. Collection of Mr.
and Mrs. Edward Smalley.

This still life was engineered with the help of photographs and a paper bag. I took several pictures of my friend's cat and then fashioned a similar cat out of a paper bag, stuffed with newspaper. By placing the "stand-in" within the still life, I was able to see how the cat's shape cast shadows over the rest of the objects to be painted.

Suggested Exercises

1. Explore your favorite room. Using a viewfinder (see "Fundamentals" chapter), discover ten spontaneous still lifes.
2. Find four compatible objects that best describe the four basic volumes: a cube, a cylinder, a cone, and a sphere. Arrange the objects in an interesting composition.
3. Select a group of objects that best describes you and your interests. Paint a "self portrait" still life.

Landscape

Watercolor and landscape go hand in hand. Because of its portable nature, this medium lends itself beautifully to painting the landscape.

The first time I ever painted a watercolor landscape from life, I was in the fifth grade, and our small art class was sitting on the sidewalk, painting a red building across the street. I'll never forget the feel of the sun on my back and my joy at watching the brush skip across the rough paper, making bright red washes and little white sparkles. I loved the feeling then and I still do. For me, it isn't the finished painting that matters most. It's the feel of the brush in hand, watching the colors mingle, and the painting evolve. It's the excitement of thought and observation, coupled with the experience of directly responding to one's surroundings.

Painting from nature can be one of life's greatest pleasures. The good feeling of creating a painting is made even greater by a heightened awareness of the senses. The smell of grass, the feel of a breeze, the sound of red-winged blackbirds all contribute to the soul of a painting. These important ingredients are lost indoors in the studio.

Of course, painting outdoors is not always a perfect picnic. You will be vulnerable to the weather, passersby, traffic, and constantly changing light. I've been run up a tree by a herd of cows, have had my paints float down river, and have been robbed of materials. I've been lost on back roads, stuck in mud, sunburned, and eaten by mosquitoes. Depite it all, it was always worth it. Even if the painting was not worth keeping, the experience was.

Mary Whyte
THE ROAD TO
STRINGFELLOWS (DETAIL)
Watercolor on paper, 20 × 27"
(51 × 69 cm), 1996. Private collection.

I was struck by the blanket of yellow flowers and cheerful red roof peeking out through the trees at this setting. Using Lanaquarelle paper, I started this watercolor on location, drawing first, then blocking in the big shapes with my largest brushes. Later, I finished the painting in my studio, adding details last.

Preparing to Paint Outdoors

Painting the landscape takes planning. There is nothing more frustrating than carting all your painting gear to a location, setting it up, then discovering that you've forgotten your water container or favorite brush. Of course, there is no way of knowing just what you will really need to paint *en plein air* until you've tried it a few times.

Basically, the equipment needed for outdoor painting is the same as for studio work, but the supplies have to be made portable. Many artists carry supplies in a tackle box. Tote bags or knapsacks are also useful. Unless you know the location has water, you should bring your own. Since you'll be exposed to the elements, dress accordingly. You don't want to cut short an otherwise successful painting session because your feet are cold or the mosquitoes have gotten the best of you. A few extra "just in case" supplies in the trunk of your car or backpack can never hurt.

Not all landscape artists use easels. Some painters prefer to sit on the ground with a board propped up in front of them. Though this practice means less equipment to transport, it can become an effort to repeatedly stretch your legs, stand back, and take a look at the work in progress.

A sturdy, lightweight easel will serve you well. A good easel will anchor down your work, thus freeing your hands to do other painting tasks. My own favorite is a collapsible, aluminum tripod easel that adjusts to different heights and tilts. It folds up easily for airplane travel.

Mary Whyte
AIRING OUT
Watercolor on paper,
20 × 27" (51 × 69 cm), 1995.
Private collection.

This painting was done a few miles from my home in South Carolina. I liked the way the red-orange roof and figures were contrasted by all the green foliage. I was careful to give everything in the background a slightly softer edge, helping it to recede. The painting was done on Arches 140-lb. cold-pressed paper.

Standing, rather than sitting at an easel will always allow more command over your painting while you work. Brushstrokes can be made more expressive with broader arm movements, and stepping back and forth from the easel helps you gain a better perspective on the work in progress. However, even the most rugged of painters can get weary and need to sit down after a while. A folding camp stool, the type found in army-navy or sporting goods stores will come in handy. Many folding stools have zippered compartments for stashing supplies and snacks, and shoulder straps for easy carrying.

If you stretch you paper in advance, you won't have to worry about it being uncooperative on location. I especially like stretching my paper on Gatorboard for outdoor work because of its light weight. Otherwise, if the paper is heavy enough (say, 300-lb.), it can be taped to a board and carried to the painting location. Clips and pushpins also work, but will not keep the paper as stationary as staples.

Here is a list of basic supplies that you'll need to paint outdoors:
- portable easel
- folding camp stool
- umbrella or wide-brimmed hat
- filled water containers
- palette
- brushes
- paints
- pencils
- eraser
- stretched paper
- paper towels
- sketchbook
- suitable clothing

A tripod-style easel is ideal for painting outside on uneven terrain. I like to hang a plastic bucket with water from my easel, and If it's windy, hang a net bag filled with rocks from the center of the easel to keep it from tipping over. If the sun is coming from behind you, a large hat will cast a shadow over the white paper, making less glare on the eyes. A good stool for painting is the Art Pack Travel Chair. It folds into a lightweight backpack that will hold all your supplies. It's available through the Art Supply Warehouse catalogue (1-800-995-6778).

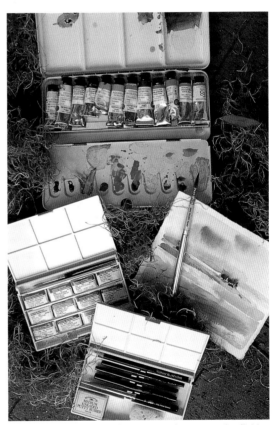

Several art supply manufacturers make watercolor field-painting boxes. Offered in a variety of sizes, some are small enough to fit in a pocket. Good-quality collapsible brushes, like the gold one and the ones shown in the box in front, are made for travel by both Isabey and Winsor & Newton.

Working on Location

If possible, I like to scout out my painting location the day before, so I'll know what I need to take and to determine the best time of day to capture the view. I'll also decide how I'll cope with the sun, wind, if there's lack of nearby water, or whatever. If you're lucky enough to plan ahead, setting up in the shade is best. I prefer to wear a hat or a visor with a wide brim. If you end up painting in direct sun, you can position yourself so that your hat casts a shadow over your paper. The glare created by the sun on stark white paper will fatigue your eyes quickly, making it difficult to judge values correctly. Sunglasses are not always helpful, as lenses may distort color.

If you plan to return to the same location, mark your spot and make note of the time when you want to start painting. Be sure to allow yourself enough time for setting up so that you don't waste the perfect light while wrestling with your easel.

Although they mean well, curious onlookers can be a distraction. For this reason, I try to find a painting location that's out of the way, with a tree or something behind me so that an audience won't be able to look over my shoulder. This may sound a bit antisocial, but after all, you are there to paint, not talk.

In spite of my efforts to paint unnoticed, I have had some interesting encounters along the way. Once while painting in Pennsylvania, I was befriended by a five-year-old Mennonite boy who looked forward to my return every morning. He would stand very quietly next to me, watching as I painted his family's dairy farm. The panoramic view was truly spectacular: a pristine white barn in the valley, cows moving lazily over the hillside, and castlelike clouds. On the second day, I glanced over at him to see him standing on his head. When I asked him why he was doing that he replied, "To give you something good to look at!"

Alice Ravenel Huger Smith
CATTLE IN THE
BROOM GRASS, AN AUTUMN
EVENING WATERCOLOR
Watercolor on paper,
18 × 13" (46 × 33 cm), undated.
Collection of The Gibbes Museum of
Art/Carolina Art Association.

This detail (near right) of the painting on the opposite page gives you a closer look at this artist's lively and free brushwork. Huger Smith (1876–1958) gave this charming watercolor a wonderful sense of light and serenity. Her rich, warm colors and textures help to bring the grasses forward in her painting, while trees in the distance are made to recede by their cooler colors and flatter shapes. The smoke rising from the chimney adds just the right touch of interest.

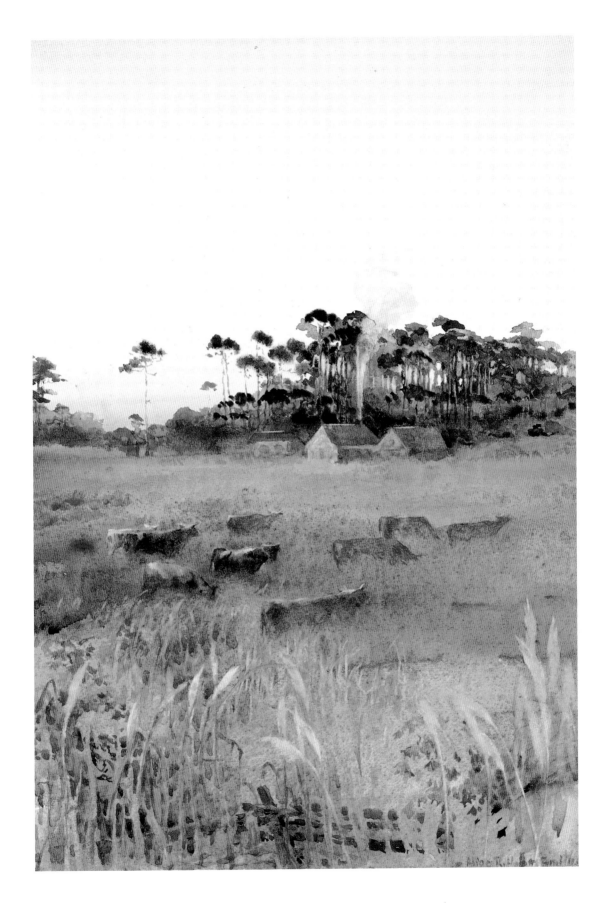

Mixing Greens

It is obvious that the dominant local color in most landscapes is green. Many landscapes contain so much green that if you aren't careful, your work can get monotonous, especially if all your foliage is painted in the same greens. If you want to paint landscapes, you will need some understanding of color, especially when it comes to mixing greens.

Beautiful greens available in tubes are viridian, phthalo, sap, and Hooker's. As tempting as these greens are, they are sometimes too intense for duplicating what is actually in the landscape. They need to be tempered, warmed, and cooled. Be careful when using phthalo green or Winsor green, as they are extremely brilliant and staining. If you go overboard with them, it is difficult to tame or lift them.

Subtle greens, such as those in the distance or in shadow areas, are more interesting if you mix blues and yellows lightly, allowing the washes to mingle unevenly and blend optically. Some of my favorite blends are cerulean and aureolin, Winsor blue and new gamboge, burnt sienna and Prussian blue, and Payne's gray mixed with Winsor yellow. The addition of a red or violet to the mixture will further gray the color and make it recede.

Begin by studying the landscape. Notice how trees farther away are lighter in value, less intense in color, and cooler in temperature. The most distant trees may actually appear more blue than green. Compare that color to grass or foliage in the foreground, which is usually much warmer and brighter in hue.

The colors you select for your landscape can help to give your painting a sense of depth. European painters of the eighteenth and nineteenth centuries interpreted this principle concerning color and spatial dimension by dividing their paintings into three parts. Foreground areas were painted predominantly a warm brown, middle-ground foliage was mostly green, and all distant areas were painted in some shade of blue. This formula continues to be used by many landscape painters to this day.

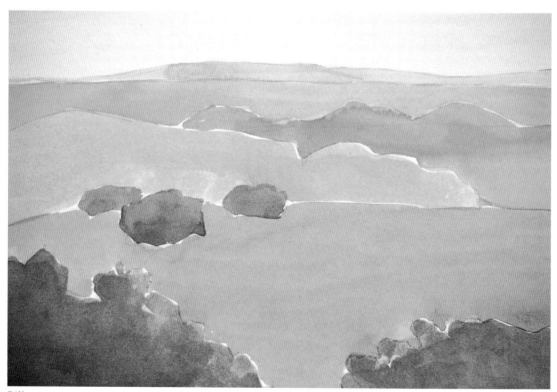

Different greens can create a sense of depth. Warmer, brighter greens come forward, while cooler, grayer greens recede in the distance. Here, I use sap green in the foreground with burnt sienna and raw sienna added in the shrubbery. The middle area is painted in Winsor green; the distant area in ultramarine blue and sap green; next, ultramarine blue and Winsor green; lastly, Winsor green and permanent rose.

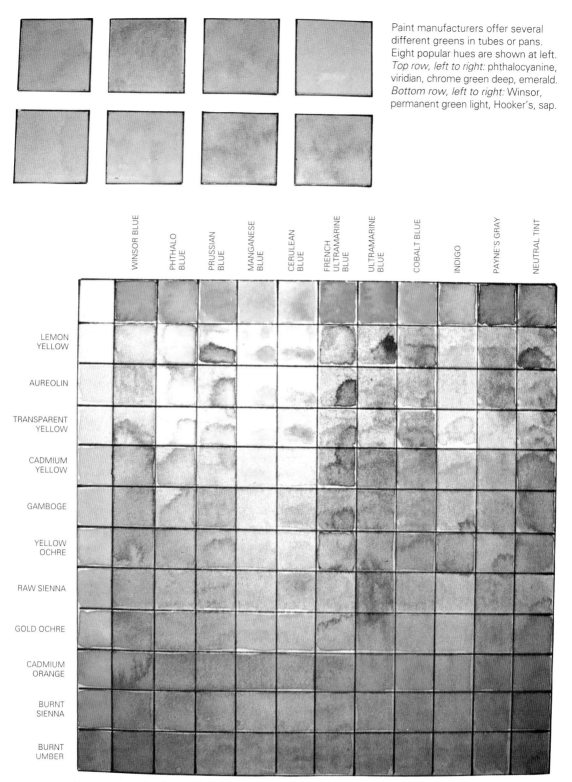

Paint manufacturers offer several different greens in tubes or pans. Eight popular hues are shown at left. *Top row, left to right:* phthalocyanine, viridian, chrome green deep, emerald. *Bottom row, left to right:* Winsor, permanent green light, Hooker's, sap.

Now compare the above tube greens to the endless variety of greens you can mix on your palette by combining yellows and blues, as shown above. Here, proportions of the two mixtures will determine if the resulting green appears warm or cool.

Trees and Foliage

Trees offer wonderful design possibilities in any landscape composition because of their complexity and variety. They are rarely perfectly symmetrical, and their endless range of shapes and sizes can be changed or exaggerated to fit your painting's concept. While it may be disconcerting to the viewer to look at a painting of a person with a disproportionately drawn arm or face, a painting of a tree that has been redesigned or reinvented is rarely objectionable.

Yet many beginning artists have a difficult time paintings trees. Their initial attempts are often fussy,

overworked, and flat. Even when they manage to detail seemingly every leaf on a tree, the resulting work lacks volume.

Painting trees is like painting anything else. You must paint the shape first, details and texture last.

First, it's important to study the shape of the tree. Remember that all objects, even trees, can be reduced to their simplest and most geometric shape: a cube, sphere, cone, or cylinder, as shown in the examples below. If you can draw the basic shapes, you can draw a tree.

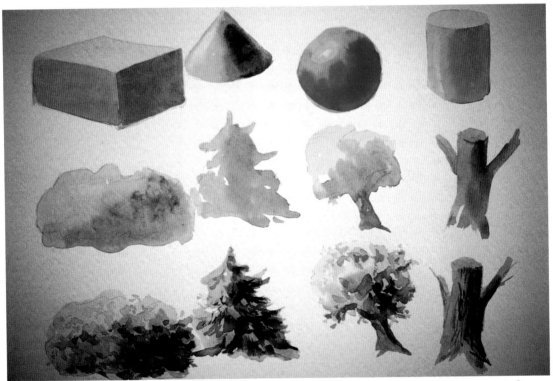

Study the shape and character of trees and bushes. Which ones are most like a cube, cone, sphere, or cylinder? Following the examples shown here, paint the basic shapes and colors of the trees and bushes you observe. As a last step, add texture and details.

Demonstration: Tree Trunk

When painting trees, it's best to stress their asymmetry to make them seem more natural. Instead of painting all the branches, select just a few that most give the tree its character. Be sure to vary the value of the tree's branches, making the ones in back lighter to increase the sense of volume.

 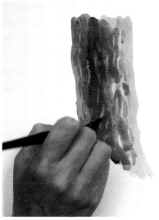 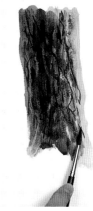

Step 1. To paint a tree trunk, determine which is the light side and paint that side first with a warm color such as gamboge to indicate sunlight. Next, select a cool color such as ultramarine blue to suggest the shade of the tree. While those two washes are still wet, paint a rich, warm, dark wash of burnt sienna, ultramarine blue, and permanent rose down the middle to make the center of the tree come forward.

Step 2. Lights hitting the high spots on the tree can be lifted out with a damp brush. Lightly scrub with the brush, then rinse and blot the brush on a paper towel.

Step 3. Holding the handle of the brush low to the paper and dragging it across the surface of the paper adds additional texture. This dry-brush technique is also helpful for painting other rough surfaces such as rocks and barns. A few dark lines help to accentuate the texture of the bark. .

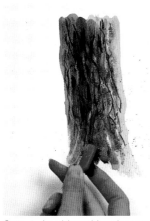 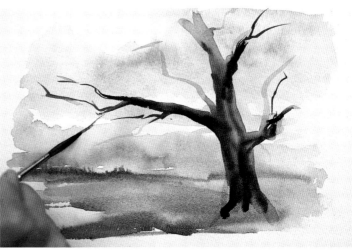

Step 4. An old toothbrush spatters a fine mist over the trunk. Spattering more than one color adds further dimension and texture. Before beginning, be sure to lay a clean paper towel over the areas you want to protect from spatter.

Because of its long narrow point, a rigger or script brush is useful for painting bare trees and branches. Let your brushstrokes follow the direction of the tree's growth, starting at the base and decreasing the pressure and width of the lines as you lift the brush upward and outward.

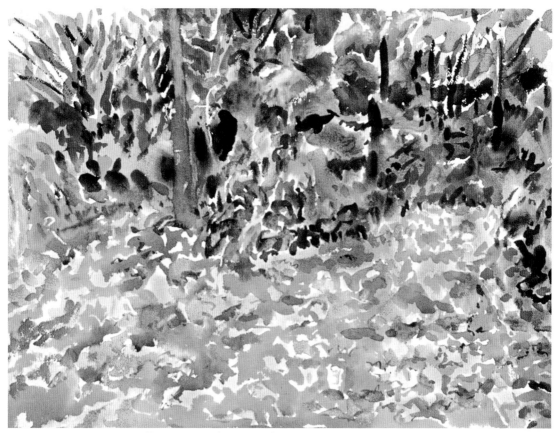

Nell Blaine
FALLING LEAVES
Watercolor and pastel on paper,
18 × 24" (46 × 61 cm), 1994.
Courtesy of Fischbach Gallery,
New York.

The character of trees and falling leaves is conveyed aptly in this painting. What may at first glance appear to be a jumble of brushstrokes is actually a carefully planned and executed composition. Notice how the vertical reds and violets in the upper half are balanced and complemented by the predominantly green shapes in the lower half. All the shapes and colors harmonize beautifully.

The detail at right of the painting above reveals even further the richness and intricacy of this artist's animated brushwork. Note the sparkle produced by all the flecks of white paper peeping through the foliage.

Skies and Clouds

The one element that sets the tone for the rest of a landscape painting is the sky. A clear, bright sky will create vibrant colors and crisp edges. An overcast sky will create more somber colors that are closer in value.

We will never see the same sky twice. Their fleeting nature is both captivating and frustrating, for as soon as a spectacular sky comes along, it's gone. As my husband's grandmother used to say,

"If you don't like the weather, stick around ten minutes. It'll change."

Capturing skies requires you to work by the seat of your pants. While painting very fast may feel nerve-racking at first, such a brief time frame does force you to boil down what you see to its essence. With essence comes strength and clarity. All this takes is gumption and a little practice. Go ahead and try it. You just might surprise yourself.

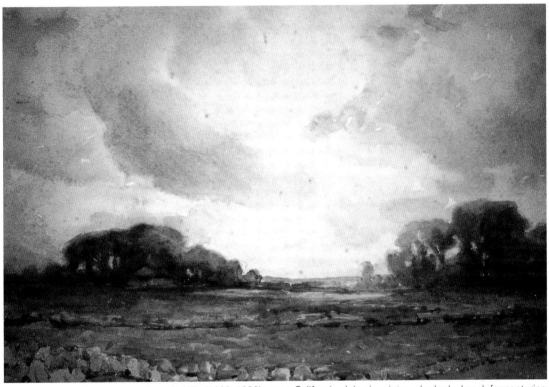

Anna A. Hills
TURNIP PATCH
Watercolor on paper, 7 × 10¹/₄"
(18 × 25 cm), 1912. Collection
of Smith B. Coleman.

Anna A. Hills (1882–1930) was a California plein-air painter who had a knack for capturing fleeting skies, whether sunny or cloudy. In this small gem of a painting, the brooding gray clouds and bright color in the foreground balance beautifully.

Demonstration: Marsh and Clouds

A watercolor portrayal of clouds generally must be done quickly, which means a large helping of painting wet-into-wet if you want to get the soft edges and blended colors. Remember that anytime you want a soft edge, either the paper must be wet or the area adjacent to where you are painting must be wet, with the two areas making contact.

You'll have more success painting an area wet-into-wet if your support board is tilted. With a lot of water on the paper and in the washes, at least you'll have more control if all the washes are moving in the same direction. Laying the board flat will move your washes in unpredictable directions, a technique with which you may also wish to experiment.

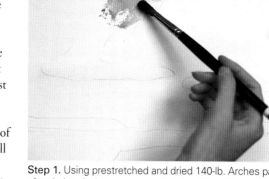

Step 1. Using prestretched and dried 140-lb. Arches paper, after I sketch the scene very lightly with a #2 pencil, first I wet the top area with clear water so that my clouds will be very soft-looking. While the water still has a shine to it I begin painting in the sky, starting at the top with phthalo blue. The slight roughness of my cold-pressed paper allows me to drag the brush on its side along the top of the cloud, suggesting the cloud's ragged edge.

Step 2. As I bring the sky downward, I add cerulean blue to warm the area closest to the horizon. On the underside of the clouds, I quickly charge in Winsor violet, letting the color bleed into the prewet area and sky color.

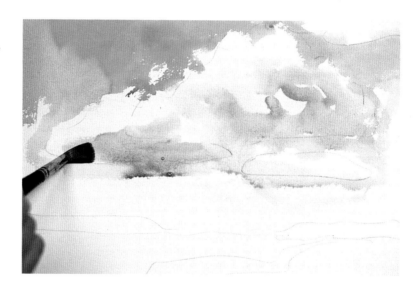

Step 3. Still painting wet-into-wet, I add yellow ochre to the sky near the horizon and then burnt sienna to warm the undersides of the clouds. When painting wet-into-wet it's important to let the paint do its own thing. Fussing too much will only cause mud. Here, a #10 round sable brush is versatile enough to paint both sky and marsh.

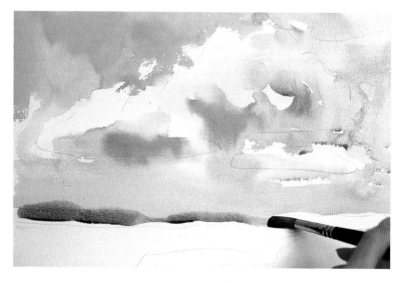

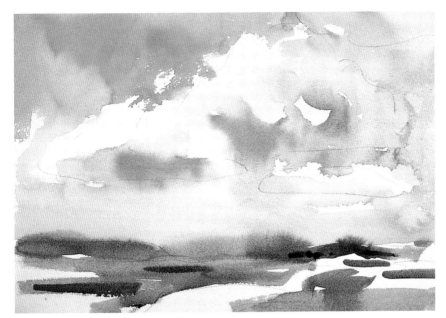

Step 4. Since objects in the distance have softer edges, I like to paint the farthest trees at the same time that I paint the sky. This allows the edges to bleed together. So, while the sky is still wet, I blend in ultramarine blue, Winsor violet, and sepia on the distant trees. Then, using various mixtures of ultramarine blue and yellow ochre, I paint the marsh.

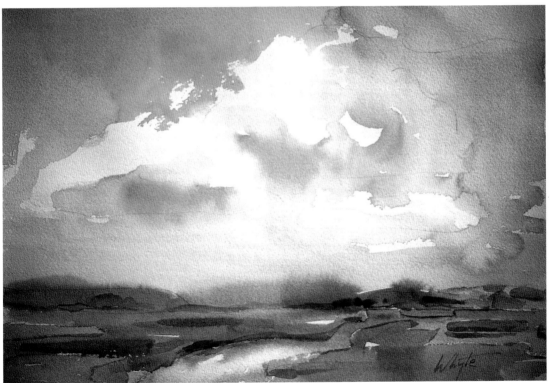

Mary Whyte
MARSH AND CLOUDS
Watercolor on paper, 11 × 15"
(28 × 38 cm), 1996. Private
collection.

Step 5. My finishing step is to darken the water and suggest a reflection of clouds in the forward area. By making the marsh darker, the cloud appears whiter.

The strength of this painting lies in its simplicity. Paintings do not need a lot of "things" in them to convey an emotion or an interesting narrative to the viewer.

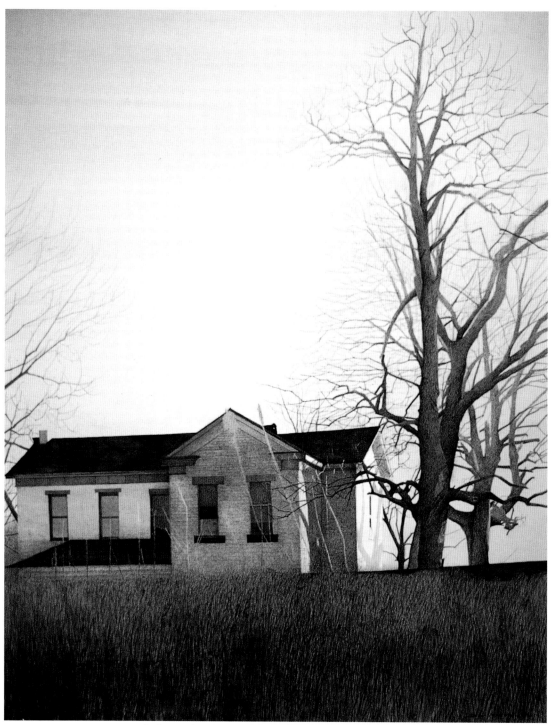

Dean Mitchell
PORTSMOUTH LEGACY
Watercolor on paper, 30 × 20"
(76 × 51 cm), 1995. Courtesy
of the artist.

A sky need not have cloud formations or strong color to be dynamic. In this painting, the simplicity of the sky provides an excellent background against which the linear shape of the tree and the geometric forms of the house are heightened.

Architectural Elements

One of the basic principles of design is contrast. Soft and hard. Light and dark. Straight and curved. Architectural elements can be interesting additions in the landscape because of their geometric shapes. The contrast of building shapes against the organic shapes of sky and foliage can add interest to your painting. Look for good shapes such as silos, church steeples, and barns, and concentrate on how each shape relates to others in your composition. Be judicious as to the placement of architectural elements. Just because there is a telephone pole or utility shed in the middle of your vista doesn't mean you have to include it in your painting. Also avoid depicting too many details in structures. Including every brick, window, and shingle can result in a rigid and lifeless image.

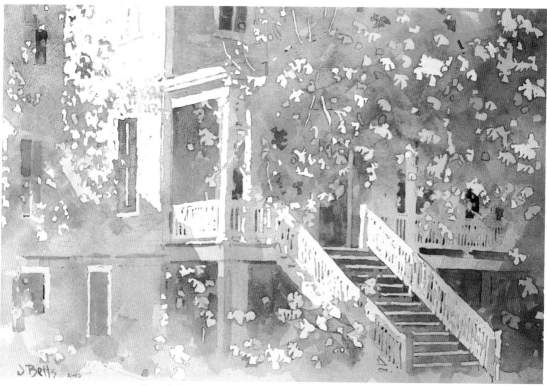

Judi Betts
SUN BURST
Watercolor on paper, 15 × 22"
(38 × 56 cm), 1994. Courtesy
of the artist.

One of the elements that makes this painting so strong is the contrast between its geometric forms and organic shapes. Try to imagine the painting without all the rectangular and linear forms, or without the lacy foliage. It simply wouldn't work.

Demonstration:
The House on the Hill

It's wonderful to depict winter in a watercolor painting because of the low light and snow colors that the season offers. This is a Pennsylvania house that I actually saw in summer, and then imagined how it would look in winter. I had photographed the scene a few years earlier and had filed the picture away for future reference.

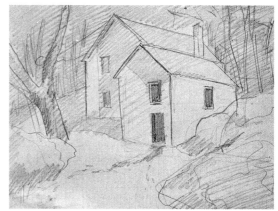

Step 1. Although this thumbnail sketch is only 4 × 6", it shows all the elements of my composition and design for a painting. My fondness for the play of shapes—the angularity of the house, the splash of soft foliage in the foreground, the sloping hillside—is what drew me to this scene.

Step 2. On Arches 140-lb. cold-pressed paper that had been stretched and dried, first I sketch in the house and trees lightly, then paint the sky with phthalo blue and ultramarine blue. With the sky still wet, I paint in a suggestion of trees in the background, using sepia and Winsor violet. For the foreground, which I also paint wet-into-wet, I choose phthalo blue and cobalt blue. While the area is still wet, I charge in Winsor green, sepia, and touch of permanent rose. Notice how these colors are more intense and darker in value than the background colors. This helps to bring this area of the painting forward. The cast shadow to the left of the house is also painted wet-into-wet, this time, using cobalt blue and permanent rose to make a blue-violet.

Step 3. For the shadow side of the house I let three colors mix themselves on the paper: gamboge and cadmium red mingled with cerulean blue. To make the front part of the house come forward, I add more gamboge to the mixture. The back half of the house has more cadmium red. Of course, I didn't really see these exact colors, but invented them to make a more lively painting. Another invention is the foot path through the snow to lead the viewer's eye diagonally into the painting up to the door.

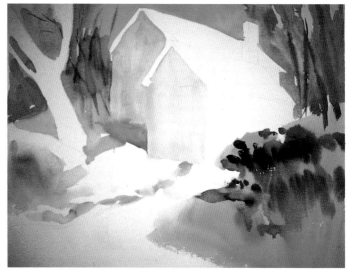

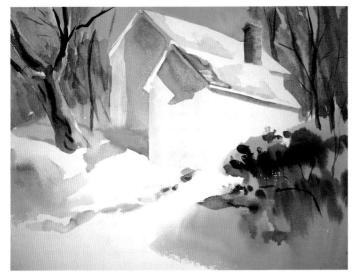

Step 4. Painting the tree on the left, I use burnt sienna on its light, warm side and phthalo blue on its cool, dark side. For dark accents I add a few quick strokes of burnt sienna and sepia. The cast shadow on the rear wall of the house is made from ultramarine blue with a yellow-orange charged in at the top to keep the shadow from becoming flat and lifeless. I paint the darker cast shadow falling under the peaked roof on the forward wall, using phthalo blue, gamboge, and a little cadmium red. The shadows on the snowy roof are a mixture of cobalt blue and cadmium red. With a few dark strokes of raw umber, cobalt blue, and cadmium red, I paint in the dark branches and texture of the tree to the left. Using the same mixture but with more water added, I suggest the base and limbs of the foreground shrubbery and background trees.

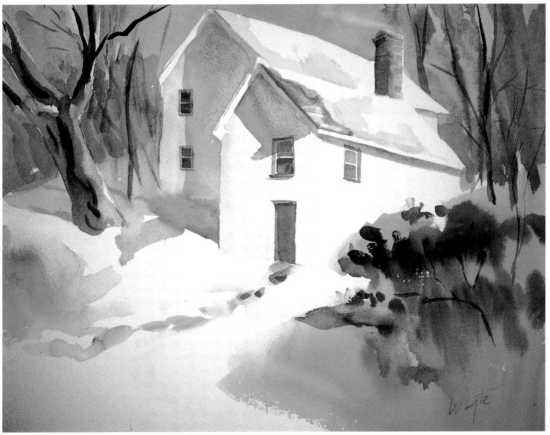

Mary Whyte
THE HOUSE ON
THE HILL
Watercolor on paper,
14¹/₂ × 16¹/₂" (37 × 42 cm),
1996. Private collection.

Step 5. I use a #6 Isabey round brush to paint in and place final details on the windows and door. The colors I choose for the windows are cobalt blue, raw umber, and cadmium red, and for the door, cadmium red and cobalt blue. I erase any remaining pencil lines with a kneaded eraser and lift out the smoke with an old bristle brush previously used for oil painting.

When painting windows, keep in mind their reflective quality. Rarely ever black, windows tend to reflect some of the color around them and are almost never the same. Here, I make the windows on the light side lighter than those on the shadow side. Using a kolinsky #6 brush, I carefully paint the dark areas, leaving behind little light lines of color beneath.

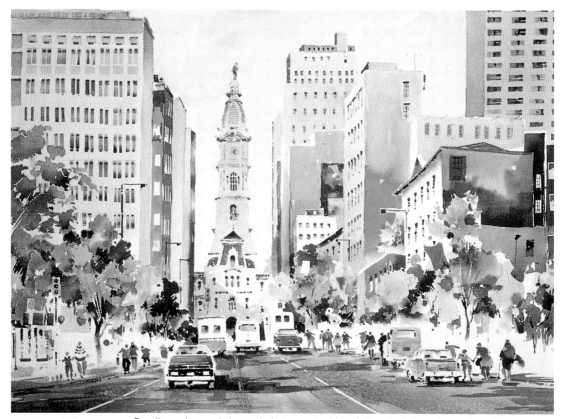

Howard Watson
BROAD STREET
Watercolor on paper,
22 × 30" (56 × 76 cm),
1994. Courtesy of the artist.

Dazzling colors and shapes help to create this painting depicting a busy city, with Philadelphia's City Hall centered in the composition. Notice how simply the artist stated the trees and figures. Notice, too, how much of the paper is left white, contributing to the painting's freshness.

Howard Watson
DOWN THE PARKWAY
Watercolor on paper,
22 × 30" (56 × 76 cm),
1995. Courtesy of the artist.

Howard Watson is best known for his cityscapes of Philadelphia. Using liquid frisket to mask out the white and painted colored shapes on the paper, Watson then overpaints with dark washes. After the washes have dried and the liquid frisket is removed, he adds small lights using Pro White, a liquid white opaque watercolor. Notice how the artist's dark wash unifies all the smaller shapes.

Demonstration: Autumn Light

Autumn foliage is always a treat for the watercolor artist. After many months of green foliage, the brief show of fall's oranges, reds, and yellows is invigorating. Just remember not to overdo it; a little color goes a long way. Also, autumnal lighting is more dramatic with the sun lower in the sky, and on sunny days, the blue sky appears even bluer contrasted to the brilliant foliage colors.

Step 1. The relationship between the large tree on the left and the smaller tree in the distance, just beyond the fence, is what prompted me to create this composition for a painting, shown here in a thumbnail sketch. The fence lends a linear quality connecting the painting's elements.

Step 2. For this painting, I sketch three or four faint lines to indicate general placement, using my thumbnail sketch for reference. To start the painting, first I lay in a very pale wash of cadmium yellow and cerulean blue over the entire sheet of stretched then dried 140-lb. cold-pressed paper. After it dries somewhat, I paint in the tree mass on the left, using cadmium yellow, cadmium red, yellow ochre, and raw sienna. In places I let the colors mingle together on the paper. The dark background area on the right is painted with ultramarine blue and burnt sienna.

Step 3. After adding more burnt sienna, to help push back the distant trees before the washes have dried, I lightly mist the area with water from a spray bottle, and then blot with a tissue. This softens the edges of the colors and blends them a bit.

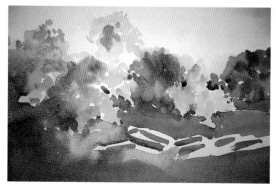

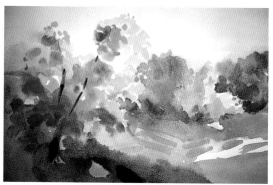

Step 4. I use a large oval mop brush in the foreground to paint in Winsor green and cadmium yellow. I place more ultramarine blue in the shadow areas, quickly painting around the fence, not worrying about any details at this point. Although I knew I wanted to include a light colored fence in this painting, I hadn't carefully drawn it at first, so when I did start painting, the results weren't exact. Painting without guidelines can produce a more spontaneous and energy-filled look, but will not add up to a well-composed painting unless you have a predetermined plan.

Step 5. I go back and soften some of the edges by lightly scrubbing them with a stiff brush. Then I increase my dark values in the left foreground by adding ultramarine blue in the ground area and raw sienna, burnt sienna, and permanent rose in the shadows of the large tree.

I pull some wash over part of the fence to break up the line, then suggest the limbs of the foreground tree by applying thin brushstrokes of sepia, rich and dark with almost no water added to it.

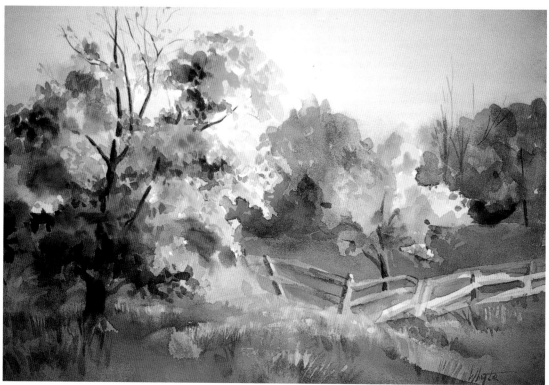

Mary Whyte
AUTUMN LIGHT
Watercolor on paper,
14$\frac{1}{2}$ × 10$\frac{1}{2}$" (36 × 26 cm),
1996. Collection of
Mr. and Mrs. Douglas D.
Milne, Jr.

Step 6. In my final step, I am most careful in leave the light areas alone so that they retain their intensity of color. But I add a few darks to the shadow areas of the big tree, using sepia and raw sienna. I also define the base of the tree trunk on the left and add some top branches , using a #4 round synthetic-blend brush and lighter values of sepia. Then I detail the foreground, using Chinese white and cadmium orange to suggest grass. To define the fence more clearly, I add shadows of ultramarine blue and sepia, and also strengthen the trunk of the distant tree with a mixture of the same but darker, and indicate ever so lightly a few other slim branches peeping out from the background trees.

Demonstration: Summer Fields

I am continually intrigued by cows and the relationship of their shapes and movement to the landscape. When seen at a distance on a hillside, cows often remind me of small figurines that can be picked up and moved at will. I also love the contrast of their black and white to the lush greens of surrounding foliage. In this painting, I wanted to stress the cow's smallness in relationship to the expanse of the sky and hillside.

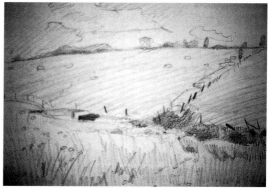

Step 1. In this thumbnail sketch, I work out how I am going to divide up a big hillside expanse of fields. The diagonal fence is added to break up the composition and to give the vista a more convincing feeling of depth. I give careful attention to where I place the cows, particularly those in the central lower left area of interest.

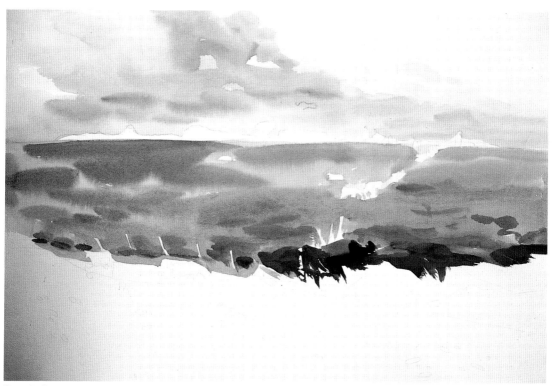

Step 2. On Arches 140-lb. cold-pressed paper that I have stretched and dried, I lightly draw in the big shapes with a #2 pencil. I'm careful to keep my drawing light so that I can make corrections easily and erase the lines as needed later. Before I begin painting, I wet the sky area with clear water, and while it's still wet, paint in clouds of ultramarine blue, sepia, and permanent rose, letting the colors mingle on the paper. Next, I wet the middle ground and immediately lay in ultramarine blue, sepia, and yellow ochre, painting from the top down so that the colors flow smoothly. I quickly paint around the sections where I will later suggest the cattle and fence. The area of the fence posts is left white as a detail to be added later. An expansive landscape like this needs some contrast, I introduce dark foliage in the right middle ground, using sepia and ultramarine blue.

Step 3. For the sky I wash in ultramarine blue and cerulean, then I paint the distant horizon trees in a light value of ultramarine blue and permanent rose. To advance the foreground, I use my warmest color, yellow ochre. I quickly paint around small areas in that section, leaving them white to suggest Queen Anne's lace, still reserving white in that area for the cows to be added later. To indicate a stream at the right, I paint its water with a pale wash of phthalo blue and raw sienna and add dark accents of the same colors with a touch of ultramarine blue.

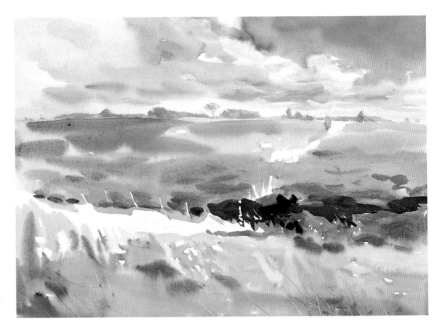

Step 4. In this close-up detail, to suggest grass I scratch out lines with my fingernail while the foreground wash is still wet. This effect can also be achieved by using the end of a chisel-handle brush or the edge of a credit card.

Suggested Exercises

1. Make a chart with as many different greens as possible. Label each segment with the color(s) used.
2. Paint six small watercolors of cloud formations from life.
3. Paint a landscape at dawn. Go back in mid-afternoon and paint the same scene, then paint that scene again at sunset or dusk.

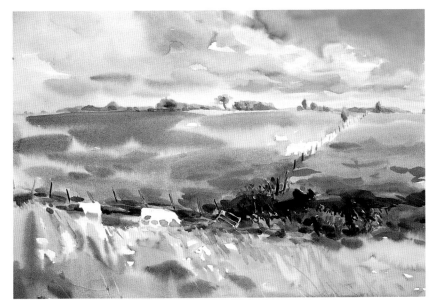

Step 5. Now that the painting's big shapes are established, I begin to add details and texture by darkening the row of trees on the horizon line slightly, giving them a little more definition with touches of ultramarine blue and sepia. I restate the bushes along the stream, using the same colors, and paint in the fence posts with a single thin brushstroke of sepia in different values for each, being sure to vary the angle of each post slightly. For the area of the muddy bank I use sepia, and for the stream on the left, I wash in ultramarine blue.

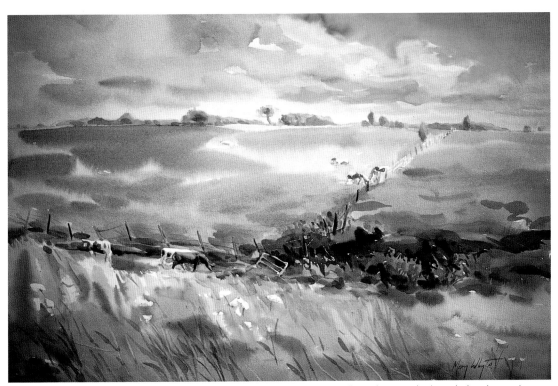

Mary Whyte
SUMMER FIELDS
Watercolor on paper, 21 × 29"
(53 × 74 cm), 1996. Private
collection.

Step 6. Since the cows are among the smallest elements in the painting, I save them for detailing in this last step, using touches of Payne's gray for the dark markings on the more distant cattle and burnt sienna, sepia, and ultramarine blue for the ones in the foreground. I also add some dark touches to the foreground to describe the grasses more fully. With a razor blade I scratch out a suggestion of the wire of the foreground fence.

Figures and Portraits

Unfortunately, many beginning watercolorists shy away from painting the figure because they think it is too difficult. I have found it to be no harder than painting anything else. True, painting the figure does require more drawing skill and at least a rudimentary understanding of human anatomy, but its method of approach is the same as painting still life or landscape. The fundamentals of design, shape, color, line, and technique still apply, despite the subject matter.

I began painting watercolor portraits when I was in high school. My first attempts were of friends who would pose for me. Later, when I realized painting was more fun than babysitting, I began doing portraits on commission. Since then, I have enjoyed many years of painting figures and portraits.

Start by making sketches and paintings of your own family and friends. Portraying the people you know and love will add an extra sense of pleasure to your mission. There's no point in tackling anything unless it interests you, so painting people who are close to you will surely hold more special meaning. Hone your figure-drawing skills by hiring a local teenager to model for you or by signing up for a life-drawing class. Carrying a sketchbook wherever you go and drawing the people around you will also enhance your artistic skills.

Mary Whyte
OCEAN BREEZE
Watercolor on paper, 26 × 20" (66 × 51 cm),
1994. Private collection.

Except in a few places where I added white gouache, all the whites in this painting are the paper showing through. The sky was painted with a variegated wash of ultramarine blue and permanent rose mixed with raw sienna. The slice of sea was painted with ultramarine blue. After it dried, I went back with a damp round sable brush and softened the line where the sky and ocean meet. This painting is a good example of how important a background can be to the overall effect of a painting. Imagine how different the look would be if the background were a solid color.

Capturing Character

With a big enough eraser, anyone can get a good likeness. By drawing and erasing, correcting and redrawing, eventually, something of a likeness will emerge. Yet, getting a strong resemblance isn't enough. Attics are filled with exact likenesses.

Character is what distinguishes a portrait beyond its physical likeness, making it compelling and memorable. It's the difference between a passport photo and a work of art. One is an image of the person; the other reflects the essence of the person.

When I hire a model or go to see a client about doing his or her portrait, the first thing I look for is what makes that person unique. I watch how a woman stands or sits—how a man holds his head. I look to see if a person's body language bespeaks one who is confident, shy, authoritative, or serene. In other words, I look for the person's character.

It really isn't that hard to come up with an evaluation of a person's essence. Think of the last time you sat next to a stranger on an airplane or in a doctor's office. After a few minutes of conversation and observation, you probably had a general assessment of that person's personality and most obvious traits. Ultimately, your job then as the artist is to portray what you have observed, selecting and editing down on paper to what is most essential.

Mary Whyte
QUEEN ANNE'S LACE
Watercolor on paper,
26 × 18" (66 × 46 cm),
1989. Private collection.

When my close friends pose for me, I am familiar with their features and characteristics, which makes it that much easier for me to get on with the business of painting. My friend Donna sat outside for this painting on what turned out to be a very chilly day. I then finished the painting later in the warmth of my studio. I used gouache for the lightest areas and for part of the lace. I created the ground first by laying down various shades of deep blue and brown. After the colors had dried, I washed off that area under running water, so that the colors would mingle and soften. Then I enhanced the texture by spattering color with an old toothbrush, being careful not to spatter into the smooth area of the skin. The model's hair is painted with burnt sienna and ultramarine blue, with highlights added using light gouache.

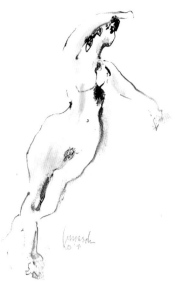

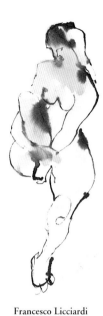

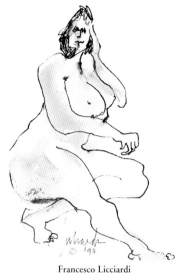

Francesco Licciardi
EXERCISE
Watercolor and ink,
18 × 11¹/2" (46 × 29 cm), 1991.
Courtesy of Phyllis Licciardi.

Francesco Licciardi
NUDE
Watercolor and ink,
17¹/2 × 11" (44 × 28 cm), 1987.
Courtesy of Phyllis Licciardi.

Francesco Licciardi
I HAVE NOTHING TO WEAR
Watercolor and ink,
12 × 8" (31 × 20 cm), 1990.
Courtesy of Phyllis Licciardi.

Some of the finest examples of figure painting in watercolor are done in a heartbeat. Although these three paintings by Francesco Licciardi (1916–1991) were made rapidly, each image accurately captures a completely different sense of character and personality. Painting fast gesture studies like these is a good way to loosen up and familiarize yourself with the human form.

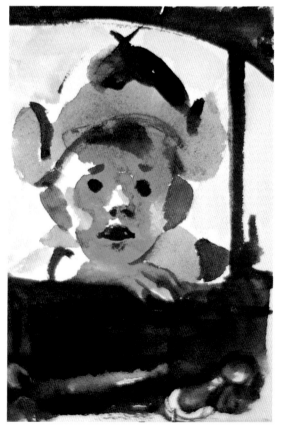

John Falter
UNTITLED
Watercolor sketchbook,
4¹/2 × 6" (11 × 16 cm), 1956.
Private collection.

This small jewel of a painting is from one of the artist's sketchbooks. Containing studies for paintings and illustrations for numerous *Saturday Evening Post* covers, Falter's annotated sketchbooks of people and places give a special glimpse into his world. It is remarkable how he managed to capture the total essence of this child with such a minimum of brushstrokes.

Working with a Model

Unlike many portrait and figure painters, I prefer to go to the model's home or office so that I'll have more of a selection of props and backgrounds that pertain specifically to that person's life. In positioning the model, the possible poses are endless and can include the whole figure or just part of it. But here are a few basic guidelines to remember.

Since most people become uncomfortable maintaining a pose for more than a half hour, it may be necessary to mark the model's position so that after a break is taken, the model can resume the exact pose when the session continues. Use small pieces of masking tape to mark the position of the model's feet on the floor, for example.

First and foremost, don't place the model in a pose, wardrobe, or setting that is unnatural to that person. An uncomfortable or strained model translates into a stilted painting. When you are trying to come up with a suitable pose, watch for clues from the model, especially when the person is at rest and relaxed. I've discovered some of the most original and convincing poses when the model was actually on break.

As a portrait and figure painter, your first job then is to make the model feel at ease. This may require certain tactics on your part, but it's well worth your time and effort. Conversation, music, and encouragement can all help to make the model feel more confident and relaxed.

Of course, the model's most comfortable pose may not turn out to be the best design for the painting. You must then take charge as the artist and orchestrate the composition. Remember, you are making a painting first; a portrait or figure painting second.

Dean Mitchell
INDIGO
Watercolor on paper,
30 × 20" (76 × 51 cm), 1996.
Courtesy of the artist.

The beauty of this painting lies in its simplicity. The figure of the woman is made even more interesting by the white free-form shapes of her patterned garment. Notice how the structures and figures in the background are made less intense in color and have less value contrast.

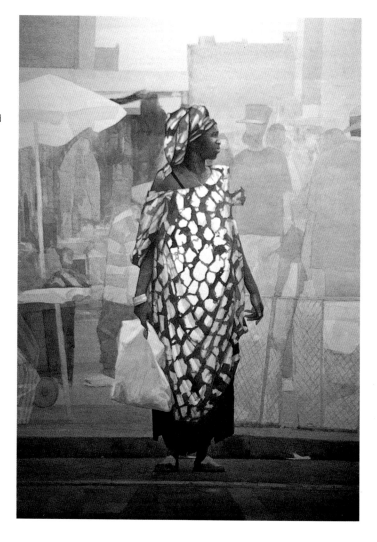

TIPS FOR POSING AND PAINTING THE MODEL

- For more accurate drawing, incorporate the use of vertical and horizontal lines. Imagine that you're looking at the model through a gridded window (or hold your pencil upright or sideways) and note which parts of the figure line up on vertical lines and which line up on horizontal lines.

- When you portray children, be aware of the difference in their bodily proportions. For instance, a child's head is much larger in relation to his body than is an adult's.

- Avoid cropping your composition at joints. A portrait that chops a person off at the knees can be disconcerting to the viewer.

- Design asymmetrically. If your figure paintings seem stiff, perhaps there is too much symmetry in their poses. Look for one shoulder to be higher than the other, for one eyebrow to be slightly raised, for the weight to be on one leg more than on the other, which will raise one hip above the other. Depict a slight tilt of the head, a curve of the back, or a crook at one corner of the mouth. Life is found in the asymmetry of form.

- When you are painting hands, concentrate on describing the gesture, instead of individual fingers. As with other subject matter, paint the shape first, details last.

- Rely lightly on photographs. Working from pictures is fine, as long as you know their limitations. A camera cannot record the amount of color that you can see with your own eyes, nor can a camera see into shadow as well as you can. If you use photos, do so for reference only, not as your main source, waiting to be copied. Remember, the camera is not the artist; you are.

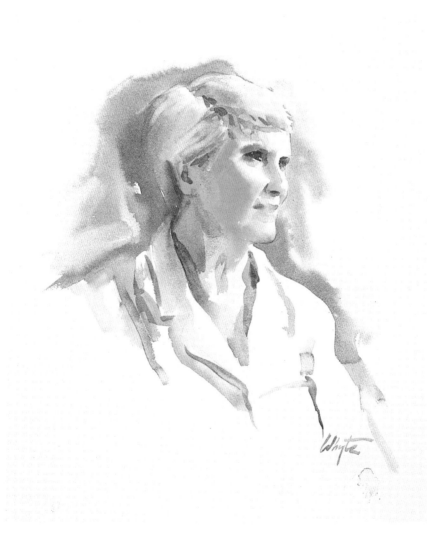

Mary Whyte
STUDY OF A
WOMAN'S HEAD
Watercolor on paper,
17 × 14" (43 × 36 cm),
1992. Private collection.

This study was painted on Arches 140-lb. cold-pressed paper that had been stretched and dried. First, I lightly sketched the contours and planes of the face. Painted in one sitting, the portrait combines both soft and hard edges as well as warm and cool color combinations, although very few colors were actually used. In the face, hair, and torso I used combinations of yellow ochre, alizarin crimson, ultramarine blue, and burnt sienna. Sap green was introduced into the background, but was made cooler to the right of the head with the addition of ultramarine blue.

Painting Skin Tones

It is imperative that you keep your washes fresh and transparent when you are painting skin tones. This may take a little planning on your part to avoid making too many revisions. Excessive correcting almost always results in muddy color.

Since skin is by nature translucent, it makes sense to select transparent colors to depict it. Use opaque colors only if your washes are kept thin or if opaques are used in combination with transparent colors. The four transparent colors I use the most when painting skin are raw sienna, burnt sienna, permanent rose, and ultramarine blue for shadow areas. But there is no formula for different colors of skin, since all skin is predominantly red, yellow, or blue. An African-American's skin may be more red or yellow than his brother's or sister's skin, just as Caucasian skin tones vary widely from person to person. I use the same colors on my palette for people of all racial backgrounds, the only difference being how much water I use in the wash to lighten or darken it.

Since skin is smooth in texture, it also makes sense to paint it with large brushes, which produce even, flat washes. I use a #10 Isabey kolinsky or a #8 Isabey cat's tongue brush. Tiny brushes produce patchy washes that read as blotchy skin. Keeping your paper on a tilt also helps keep your washes smoother looking, since gravity helps pull the flow consistently downward.

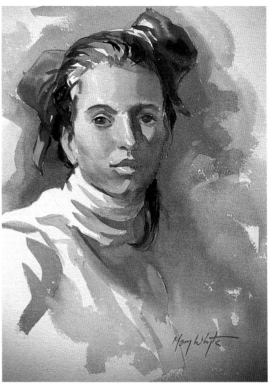

Mary Whyte
PURPLE BOW
Watercolor on paper,
17 × 13" (43 × 33 cm), 1991.
Private collection.

Generally the fewer colors the better when mixing skin tones. Fresh skin color depends on transparent-looking washes and a good balance between warm and cool colors. These are some of the color combinations I frequently use: *Top row, left to right:* raw sienna and permanent rose; burnt sienna and dioxazine purple; yellow ochre and cadmium red. *Bottom row, left to right:* raw sienna, cerulean blue, and permanent rose; raw sienna, permanent rose, and ultramarine blue.

One of the challenging aspects to painting skin is to keep it fresh-looking especially in the shadow areas. As in this painting, I believe a wet-into-wet technique works best. Keeping my paper tilted, the colors I painted downward here for the flesh tones are raw sienna, alizarin crimson, and burnt sienna. After the initial washes for the light side of the face dried, I painted in the shadow side wet-into-wet, using Winsor green, ultramarine blue, raw sienna, and alizarin crimson. When combining this many colors, it's imperative to put them down *once* and resist the temptation to manipulate them further. For the folds and shadows in the model's paper-white shirt I used light washes of alizarin crimson, burnt sienna, and ultramarine blue; for her hair I chose burnt sienna and ultramarine blue, letting white space peak through to suggest highlights. For the background, using a 1" flat wash brush I painted in a bright Winsor green with touches of blue and violet, using angular strokes to echo shapes and brushstrokes in the figure.

Demonstration: Painting the Head

Your first attempts at painting the figure might best be limited to studies of the head, using one color such as sepia. In the beginning, don't worry about getting a perfect likeness of the model. This will come later as your drawing and watercolor skills progress. Start with the basic volumes of the head, keeping in mind the four geometric forms: the cone, cube, sphere, and cylinder. Having the light source directed on the model from one side will make the shapes of facial features easier to decipher.

When you portray the head and face, remember, as noted above, that the smoothness of skin texture calls for the application of smooth watercolor washes. Be careful not to use too much water in your washes to avoid a distracting "backwash" from creeping up into the face. Use a large, round brush and hold your paper on a slant.

The value contrasts in this color photograph illustrate an important point about posing models for portraits. I find that faces are much easier to draw and paint if the light source is coming from the side. This way, the lights, middle tones, and darks are more easily interpreted.

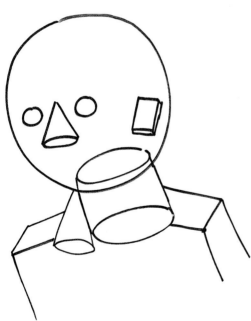

Everything we see can be boiled down to one or a combination of the four basic geometric forms; the head and figure are no exception. If you can picture the head as a combination of different shaped volumes, it is easier to draw. For instance, the head and eyes can be seen as spheres; the neck as a cylinder; shoulders and torso as a cube, and so on.

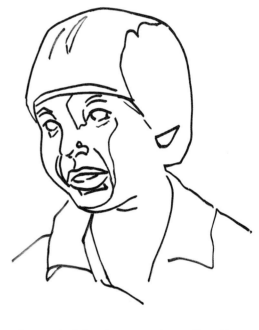

Learning to paint is learning to see shapes. Here, I have broken up the head into the biggest shapes I see, including shadow shapes. Seeing two distinct shapes in the hair will help me as I begin to paint.

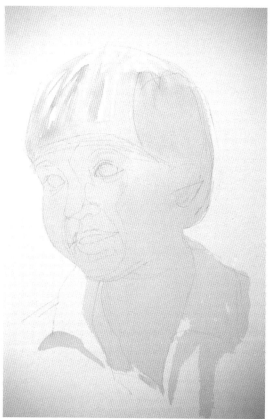

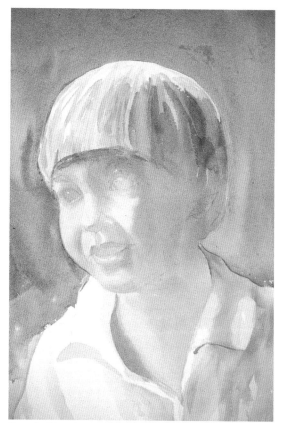

Step 1. On Whatman 140-lb. cold-pressed paper that has been stretched and dried, I draw in the shapes of the head. Then I lay in my light values using sepia, starting at the top and pulling the wash downward. I use sepia here instead of color because I want to concern myself only with the lights and darks (the values) of the face and shoulders. This is a good way to prepare for a portrait painting before doing one in color. Except for the highlights of the eyes and lips that will be added last, there are no true whites anywhere on this face, so my first washes of sepia using a #10 round kolinsky brush cover everything. For the boy's hair, I paint in quick downward strokes leaving the white of the paper where I want to suggest highlights.

Step 2. After the light washes have dried, the middle tones come next. By painting around the already established lightest tone of the face I begin darkening areas to express contour and shadow. It's important at this stage to be thinking in terms of shape and value and not details, although in this step I have defined each facial feature more clearly, depicted the cast shadow from the hair on the boy's forehead, and added a few darker values to heighten the appealing contrasts in his sun-streaked hair. I use an oval mop brush for wider brushstrokes on the shirt. Narrower strokes for contrast are made with a #4 round sable brush.

Mary Whyte
KYLE
Watercolor on paper,
11 × 15" (28 × 38 cm), 1996.
Collection of Mr. and Mrs. David Espenshade.

Step 3. The darks and details are last. I complete the texture of the hair and paint in the darks of the eyes, being careful to work around the highlights. If you accidentally paint over highlights after your picture is dry, you can pick them out again with the tip of a razor blade, exposing the white paper beneath. The mouth, nose, eyebrows, ear, and neck are defined further, and the background is darkened to increase the sense of light and make the shirt appear whiter.

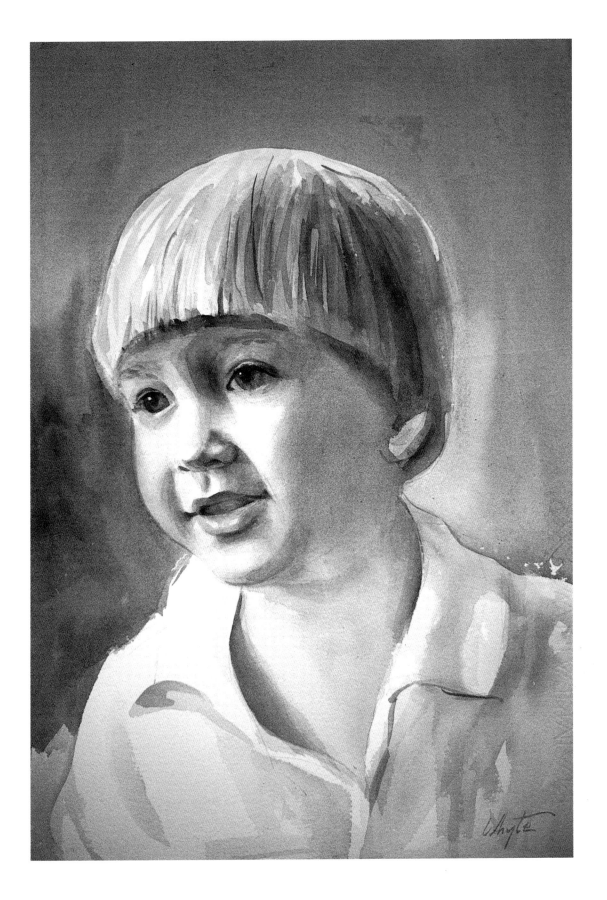

Demonstration: Painting the Figure Against a Background

Creating a background for a figure painting adds another dimension to the look of the finished work. As well as enhancing the figure, a background narrates a sense of location and environment.

When choosing a setting, it's generally best to keep it simple and uncluttered, particularly around the area of the model's face. Select background colors that are harmonious with the overall composition so they won't overpower the figure. Pick and arrange props based on their compositional value rather than on their literal characteristics.

Step 1. On Fabriano 140-lb. cold-pressed paper that has been stretched and dried, I lightly draw in my composition. The model's tiny stature is emphasized by posing her standing, with her elbows raised up to reach the windowsill. My first wash of skin tone is a combination of permanent rose, ultramarine blue, and burnt sienna, which is painted wet-into-wet, with a bit more blue and rose in the cheek area and forehead to simulate cool light on her face. I use permanent rose, ultramarine blue, sepia, and burnt sienna for her apparel.

Step 2. Posing this little girl looking out a window, first I wet the background with clear water and then apply phthalo blue and yellow ochre on the wall areas, reserving the white paper for the windowsill, window frame, and tiny windows seen on the building across the street. I lay in ultramarine blue, permanent rose, and raw umber to suggest a brick-red building, and add some brushstrokes of Winsor green with some permanent rose on the tree in front of it. After the background blue and yellow are dry, I glaze over them with a violet-blue color, while at the same time pulling the background wash over the lower area of the child's torso. I adjust the color of her shirt by adding a glaze of blue-violet and touches of raw sienna. For the hair, I use a combination of sepia and Payne's gray. To give it a soft edge, I paint the pony tail into the background while the blue-violet glaze is still wet.

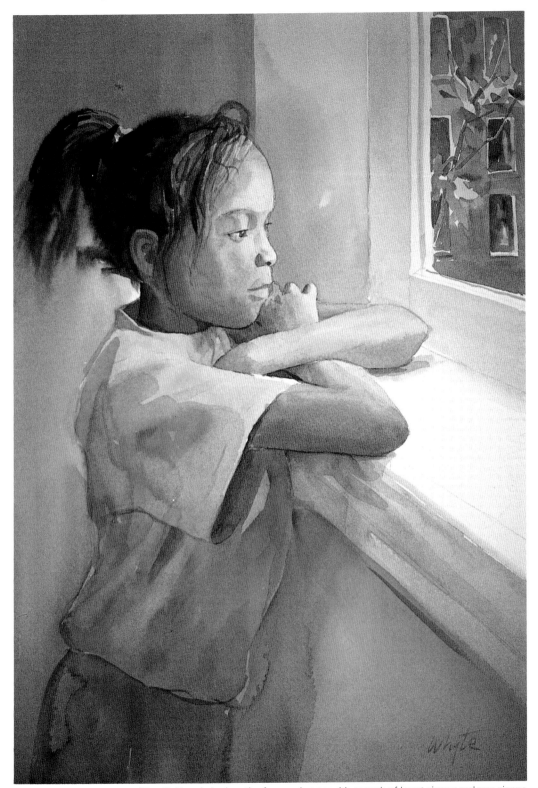

Mary Whyte
LONGING
Watercolor on paper,
10 × 14" (25 × 36 cm),
1996. Private collection.

Step 3. Now I shadow the face and arms with a wash of burnt sienna and raw sienna with ultramarine blue on the neck and underside of the arms, and add facial features using subtle tones of raw umber and burnt sienna. Notice how I detail the windows across the street, subtly suggesting a figure in one and other tiny details by lightly applying blues and browns wet-into-wet to keep the painting simple and direct. The entire painting was completed in one sitting using a #10 round kolinsky brush.

Demonstration: Painting the Nude

Whether or not you intend to pursue a career of painting the nude, drawing the human figure is excellent practice for all other subjects that you'll depict in watercolor. Painting the human figure demands a keen sense of proportion, which in turn strengthens your observation and drawing skills.

For centuries, art schools have required classes in life drawing, and for good reason. Being adept at understanding and drawing the human form can only increase your virtuosity in other areas of art. There are no shortcuts to learning how to draw. Any subject matter can be used for learning, since all that we see around us has form, is affected by light, and is situated in space in proximity to other objects. So whether it's landscape, still life, or figures that you choose—just draw. There are many good books devoted just to developing drawing skills, and such courses are offered by many schools. I recommend both avenues.

Suggested Exercises

1. Using charcoal pencil, draw a close-up study of one of the plants in your home. Pick an area of the plant no more than 3 × 4" and draw it on a sheet of paper 11 × 14" or larger. Concentrate on light and values.
2. Using a black marker with a fine point or a Rapidograph-style pen, draw the view from one of your windows. Using direction and density of line, indicate light, perspective, and depth on a paper 11 × 14" or larger.
3. Using a soft pencil (#4B or #5B) and a sheet of paper 11 × 14" or larger, position yourself in front of a mirror and draw a self-portrait. The drawing can be just your face or your entire figure against a background. Focus on capturing a sense of form and texture

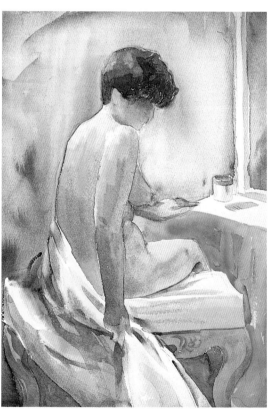

Step 1. On Winsor & Newton 140-lb. cold-pressed paper that I've stretched and dried, I loosely sketch in my composition. I establish the background color first with phthalo blue and transparent yellow. Toward the lower part of the background, I charge in some permanent rose to gray it down a bit while it's still wet. I also pull the color into the foreground area of the fabric that the model holds so the figure won't have a cutout look.

Step 2. Using permanent rose and raw sienna for the flesh tones, I lay in my wash and while it is still wet, I charge in sap green near the figure's lower back. For her brown hair I choose yellow ochre, sepia, and ultramarine blue. The fabric drape is painted with transparent yellow, raw sienna, and cadmium red. The seat cushion remains mostly paper white, as do the dressing-table surface and mirror frame.

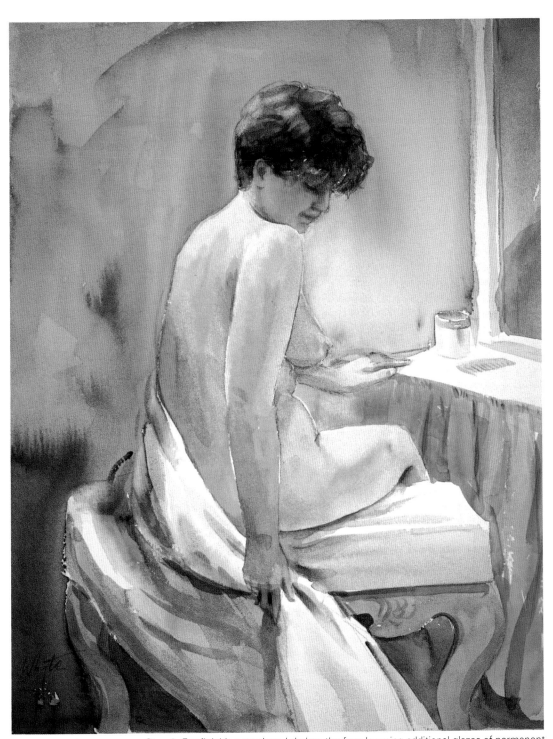

Mary Whyte
**NUDE WITH YELLOW
AND GREEN**
Watercolor on paper,
12 × 14" (31 × 36 cm), 1996.
Private collection.

Step 3. For finishing touches, I darken the face by using additional glazes of permanent rose, raw sienna, and ultramarine blue. I lift out highlights on the hair by scrubbing it with a stiff, damp, bristle brush. I add a few darks to the fabric folds, stool legs, and within the mirror to suggest an image there.

Demonstration: Painting More Complex Works

After you've mastered the fundamentals of watercolor, you may wish to tackle more complicated images. The procedure should remain the same whether you complete your painting in a minute or in a year's time. As the artist, you must still develop your concept through sound design and practiced technical skills.

But keep in mind that more inventory in a painting does not guarantee a better product. Generally, *less* is more. So, if you are going to be attempting more complicated images, be sure that each addition to your composition is in keeping with the painting's essence.

These are some snapshots that I took as reference for a painting that I had in mind, turning a composite of these pictures into my final composition. As a serious beginner in watercolor, you, too, should be on the lookout for good photographic material to augment subject matter painted from life.

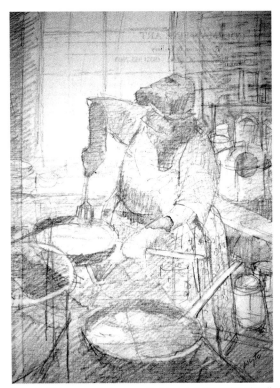

Step 1. Using my photos as reference, I make a thumbnail sketch that clarifies my overall concept, which came to me while watching the women from a local community-center fish fry for a fund-raising dinner. My sketch shows both the design and some value patterns that I'll build into my watercolor painting.

Step 2. As usual, I paint the biggest shapes first, starting with a background wet-into-wet application of ultramarine blue and raw sienna. For the window curtain, I mix a wash of aureolin and cerulean. The stove is painted with Payne's gray and sepia; the large pot in the foreground with sepia, raw sienna, and Winsor blue.

136

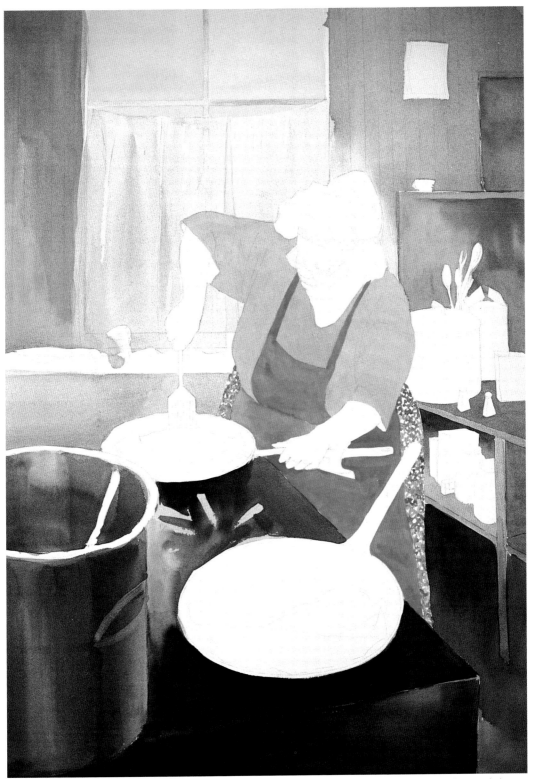

Step 3. I darken the background gradually while keeping it low in value overall. Darkening the background shapes will eventually make the window light appear brighter. On the wooden counter to the right I paint around the cooking implements and supplies with shades of sepia and raw sienna. I use cerulean blue with a touch of Winsor green for the woman's blouse. To describe the tiny pattern of her skirt, with a #4 sable brush I apply little quick dabs of red and blue, making sure to leave bits of white paper showing through . Although my model wasn't actually wearing an apron, I created one so that I would have a diagonal apron strap leading to her face.

137

Step 4. I paint in the figure's skin tones, using combinations of sepia, ultramarine blue, and burnt sienna. To portray the rims of her eyeglasses, I use a wash of raw sienna; for the glass, cerulean blue with a little sepia applied wet-into-wet. Her hat is painted in Winsor blue and Payne's gray. Detailing the items on the shelves, a variety of colors are employed, simulating those found on the actual food packages depicted. For the lettering on boxes, note that I never really spell out the labels completely.

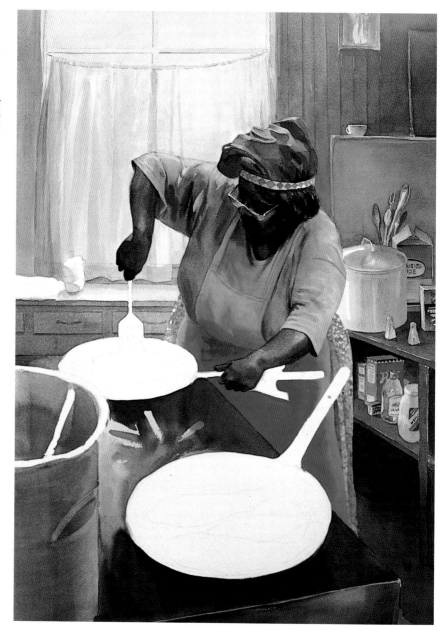

Suggested Exercises

1. Take your painting supplies and a small watercolor sketchbook with you to a mall or park and paint ten small monotone studies of people in action, using either Payne's gray or sepia. Spend no more than five minutes on each study. Concentrate on the action rather than the clothing of your subjects.
2. Create six different watercolor skin tones, using no more than three colors for each combination. Record next to your color swatches the names of the colors you used for future reference.
3. Ask a family member to pose for you. Paint that person's portrait without the aid of photographs.

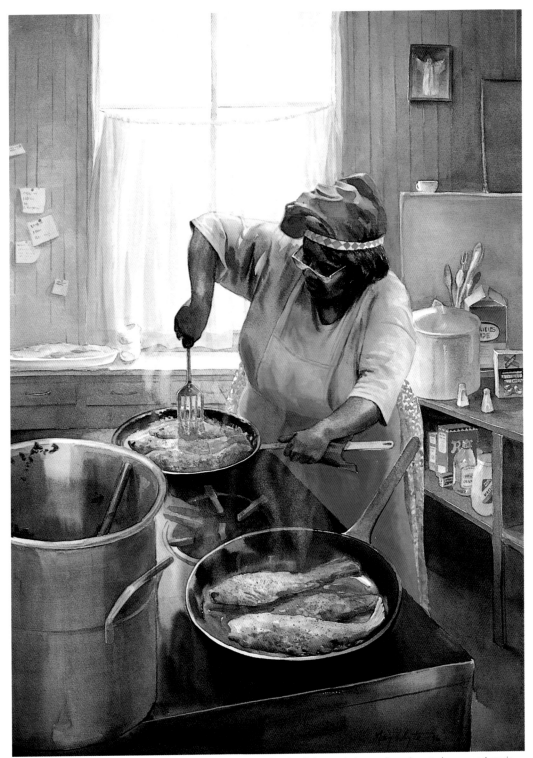

Mary Whyte
FISH FRY
Watercolor on paper,
21 × 29" (53 × 74 cm),
1996. Private collection.

Step 5. I select warm colors for the fish—cadmium yellow, burnt sienna, and sepia—a good contrast against the cool colors of the woman's clothing. For the darks of the frying pans, I use Payne's gray and sepia, then suggest the smoke rising from the pans by lightly scrubbing the area with a damp, stiff brush, then blot that section with a paper towel. My final touches include details on the walls flanking the window, and painting the shiny handles of the pans and the spatula, for which I use Payne's gray and sepia. I'm careful to leave narrow slivers of white paper showing on the edges of the spatula and frying pans to indicate their highlights.

Mary Whyte '

Afterword: Where to Go from Here

Most artists would agree that sound technical skills are an important ingredient for meaningful expression. However, even the most skillfully executed watercolor will be meaningless if it is void of emotion. A tightly rendered painting of a sunset or a basket of apples is simply not enough to warrant critical merit. You must be able to show the viewer what you *feel* about that sunset or still life in order for the painting truly to say something. It's the difference between fine art and fine wallpaper.

As the artist, your job is to create a work that appeals to the senses. Strive to transform everyday subject matter into a beautiful work of art that transcends the commonplace. Tell your own story.

I call this "painting from the heart." To create a work of art that is refreshing, imaginative, original, and even surprising, you must reach from within. This is not always as easy as it may sound, since it requires you to know yourself well and identify what truly moves you.

Mary Whyte
ANDREW
Watercolor and crayon,
24 × 19" (61 × 48 cm), 1992.
Collection of Nina M. Dana.

When I went to this young boy's home to do his portrait, he saw me getting out my art supplies and decided to paint, too. He told me he was going to make a picture of a shark. The very first thing he did was sign his name to his picture. I was tickled by his self-confidence and wondered what we, too, as artists might accomplish if we signed our names first, every time we started a painting.

FORMING A PERSONAL VISION

So how do you know what to paint? And how do you paint from your heart? One suggestion I have for pinpointing what it is that really moves you is to make your own "Five Senses List."

Begin by listing the five senses in a pocket-size notebook: taste, sight, sound, touch, and smell. Then, over the course of the next week or two, enter ten things in each category that really move you. Don't write what everyone else would write, such as a rose for smell or a rainbow for sight. Your list should be as personal and as individual as you are. For instance, I had a student who wrote under the heading "sound,"

"My horse running in the pasture at night." I knew that was something no one else could have written.

Making the "Five Senses List" may take some careful thought. Ideally, your list will begin to reveal that which holds the most meaning and emotional stimulation in the world around you. Ultimately, it may not be the specific objects on the list that you want to paint, but something about their intrinsic characteristics, such as motion or color.

Forming a personal vision never ends. It is a lifelong learning process that requires study, experimentation, and the realization of your own true individuality.

Mary Whyte
THE HOMECOMING
Watercolor on paper,
19 × 25" (48 × 63 cm), 1994.
Collection of Mr. and
Mrs. Kenneth L. Fry.

Painting objects and people that are meaningful to you will never be time wasted. For this still life, I selected the blue-and-white china that I had depicted many times before. The little girl in the background was a neighbor who often stopped by after school for a visit. I set up a still life in my studio, including the dishes, glasses, pitcher, and fruit, and painted all those items from life. Then I added the flowers and background, which I made up. I took a photograph of the little girl kneeling on a chair in my studio and used it for reference. The painting was done on Arches 140-lb. cold-pressed paper, and all of the brightest whites in the painting—of the flowers, pitcher, dishes, and linen—are the white of the paper.

CONCLUDING THOUGHTS

Desire is its own best teacher. Learning to paint in watercolor is like learning to do anything of significance. The degree of your success will depend on the amount of sincere effort you give.

Keep searching and growing. If something matters enough to you to want to paint it, eventually, you'll find the artistic means to do so—and the time to commit to working at it, even if your life is crowded with other demands. As you progress in your artistic career, you will gain confidence and momentum and will surprise yourself with what you can accomplish. As Thomas Edison said, "If we did all that was in us to do, we would truly astonish ourselves."

Janet Walsh
SUNDANCE
Watercolor on paper,
29 × 40" (74 × 102 cm),
1996. Courtesy of the artist.

It is always easy to spot a Janet Walsh painting since her work is as individual and unique as she is. Often her paintings depict everyday objects but are made even more special by her use of color and interesting shapes. The sunflowers, the focal point of the composition, are made to appear even brighter by the surrounding touches of blue-violet. Their jagged, round shapes are complemented and framed by the horizontal and vertical lines of the window treatment behind.

Index